The GROWN-UP'S GUIDE
TO MAKING ART with KIDS

25+ FUN AND EASY PROJECTS TO INSPIRE YOU
AND THE LITTLE ONES IN YOUR LIFE

Lee Foster-Wilson

Brimming with creative inspiration, how-to projects, and useful information to enrich your everyday life, Quarto Knows is a favorite destination for those pursuing their interests and passions. Visit our site and dig deeper with our books into your area of interest: Quarto Creates, Quarto Cooks, Quarto Homes, Quarto Lives, Quarto Drives, Quarto Explores, Quarto Gifts, or Quarto Kids.

© 2019 Quarto Publishing Group USA Inc.
Artwork and text © 2019 Lee Foster-Wilson

First published in 2019 by Walter Foster Publishing, an imprint of The Quarto Group.
26391 Crown Valley Parkway, Suite 220, Mission Viejo, CA 92691, USA.
T (949) 380-7510 **F** (949) 380-7575 **www.QuartoKnows.com**

Walter Foster Publishing titles are also available at discount for retail, wholesale, promotional, and bulk purchase. For details, contact the Special Sales Manager by email at specialsales@quarto.com or by mail at The Quarto Group, Attn: Special Sales Manager, 100 Cummings Center, Suite 265D, Beverly, MA 01915, USA.

ISBN: 978-1-63322-739-2

Digital edition published in 2019
eISBN: 978-1-63322-740-8

Page Layout: Erin Fahringer
In-House Editor: Annika Geiger

Printed in China
10 9 8 7 6 5 4 3 2 1

TABLE OF CONTENTS

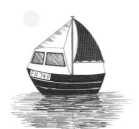

Introduction

Oh, to be able to view the world through a child's eyes! Creativity seems to come so naturally and unselfconsciously to children. With a little encouragement, they are happy to draw and paint almost anything—they allow their imaginations to run wild and come up with all kinds of subjects and stories. But what happens when the children in your life ask you to draw or paint with them? Are you able to accurately render their requested subjects?

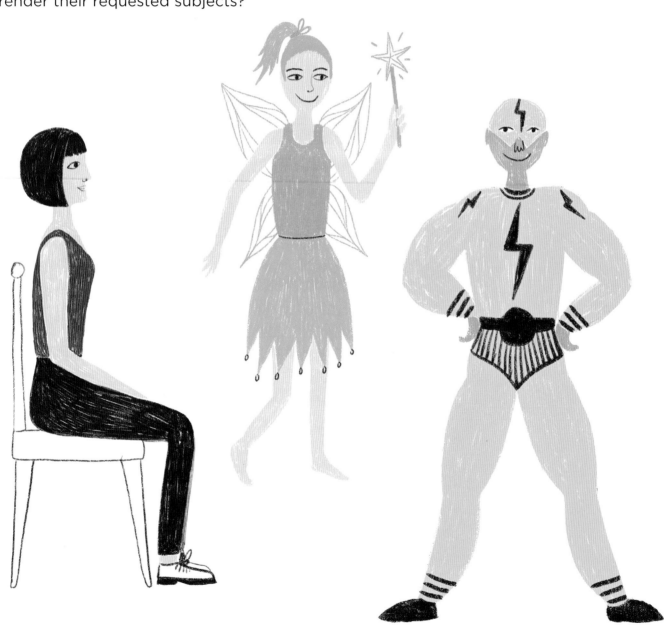

If the answer is "no," but you've always wanted to learn to draw and make art projects with and for kids, this book is especially for you! Although my simple tutorials won't teach you how to work realistically, you will learn to draw and paint in a way that is fun and appealing to children. You'll also learn how to draw and paint with confidence. Included are practice spaces where you can make notes or sketches for future reference as well.

Once you have mastered a few basic drawing techniques, you will be able to tackle those requests with more than a stick figure or a cat that looks like a dog and a dog that looks like a horse. My hope is that this knowledge will also inspire kids to create art of their own.

And what should you do with these drawing and painting skills? I've covered that too! In this book, you will find easy craft projects for you and your kids to do together. (These have all been tested by my own children, who enjoyed them immensely.)

Now grab your art supplies, and let's dive in and have some fun!

Lee Foster-Wilson

TOOLS & MATERIALS

You probably already own many of the art supplies used in this book! Here's what I recommend when you and your kids are ready to start drawing and crafting together.

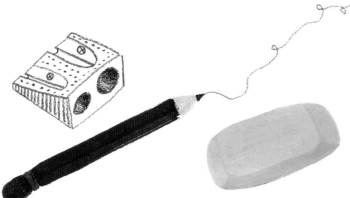

GRAPHITE PENCIL, PENCIL SHARPENER, AND ERASER Use these for sketching. I prefer an HB or a 2B pencil.

FELT-TIP MARKERS & FINELINER PENS
A good selection of markers is necessary when making art with kids. If you have young children, you may want to choose the washable kind! Fineliner pens aren't necessary, but they work well for adding detail to drawings.

PAINT Thick poster paint and/or a tray of watercolors make fun, accessible tools—and they're often washable too!

QUALITY CRAYONS
These make drawing and coloring easy for even the youngest of children.

PAINTBRUSHES & SPONGES Make sure you have a few paintbrushes and sponges of various sizes. Little hands will find thicker brushes and sponges easier to hold and can use them to add lots of color, while older children and adults may want smaller brushes and sponges for creating fine detail in their artwork.

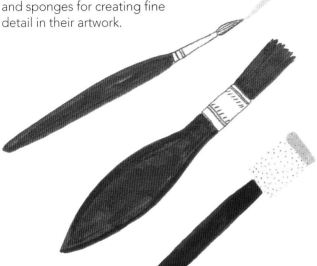

PAPER & CARD STOCK Basic printer paper is great for practicing drawing, and you will need plain white paper for several of the projects in this book. Colorful paper and cardboard make fun surfaces, too. You may find that thicker paper or card stock will work better for the painting projects.

You can also reuse paper and cardboard found around your home. Old cereal boxes, index cards, shoeboxes, and unfolded envelopes can be used as drawing and painting surfaces.

Here are a few more items that you may want to have on hand when making art with your kids:

- Colored pencils
- Glue
- Tape
- Craft scissors

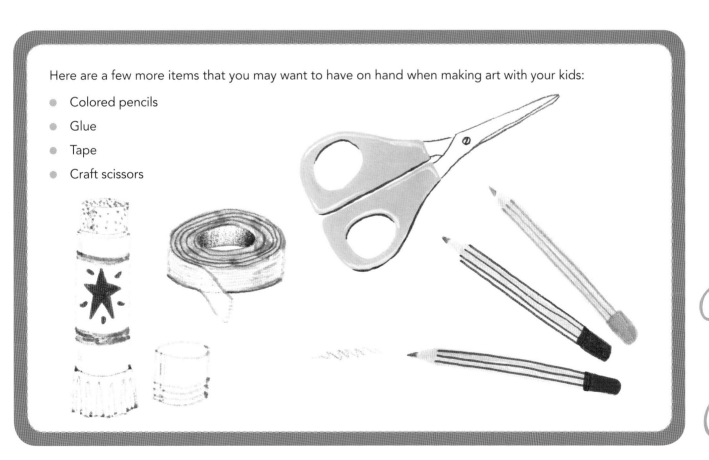

Color Basics

If you have kids who enjoy crafting, chances are you probably already own a wide range of colors, whether you and your family like to work with markers, crayons, watercolor, acrylic paints, or something else. There are so many colors out there that it's impossible to own every single one, however, and you may want to mix and match colors to create different shades. This is where having a basic understanding of color theory will come in handy!

THE COLOR WHEEL

The color wheel has been around for centuries, but it remains the best tool for learning about colors and how they relate to one another. It can also be used as a reference when mixing colors.

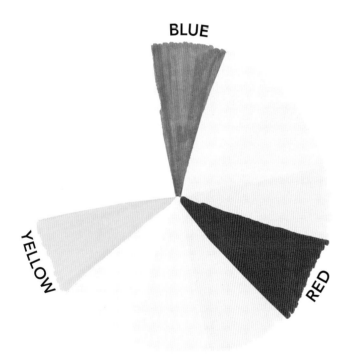

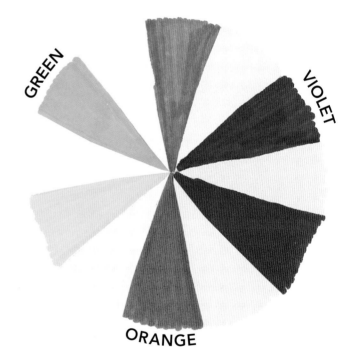

At the heart of the color wheel are the three **primary colors**: red, yellow, and blue. Primary colors cannot be created from other colors. They can, however, be mixed with each other to make any other basic color.

Mix primary colors in equal amounts to create the **secondary colors**: orange, green, and violet.

HOW TO MIX SECONDARY COLORS

Use the following primary color combinations to create secondary colors.

● + ○ = ● **ORANGE**

○ + ● = ● **GREEN**

● + ● = ● **VIOLET**

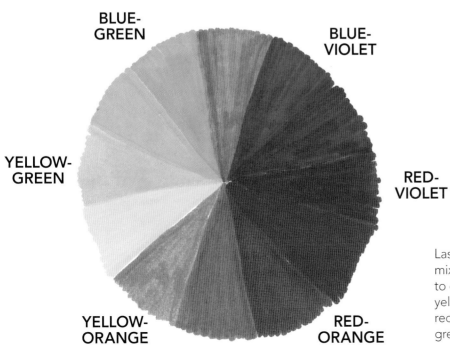

BLUE-GREEN

BLUE-VIOLET

YELLOW-GREEN

RED-VIOLET

YELLOW-ORANGE

RED-ORANGE

Lastly, primary colors can be mixed with secondary colors to create **tertiary colors**: yellow-orange, red-orange, red-violet, blue-violet, blue-green, and yellow-green.

HOW TO MIX TERTIARY COLORS

Use the following primary and secondary color combinations to create tertiary colors.

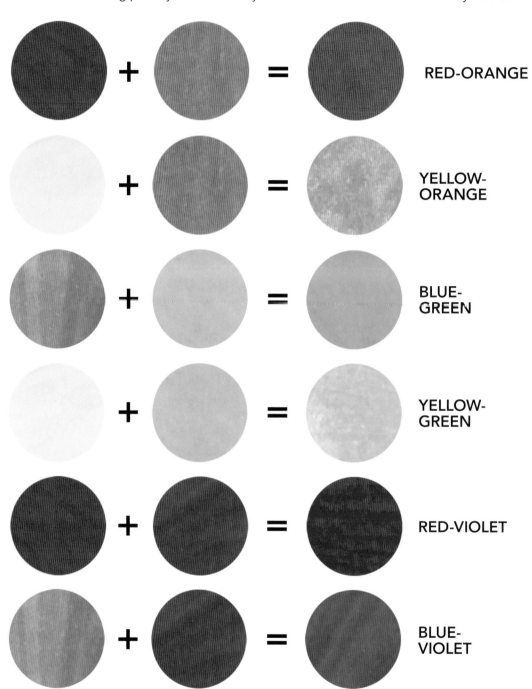

RED-ORANGE

YELLOW-ORANGE

BLUE-GREEN

YELLOW-GREEN

RED-VIOLET

BLUE-VIOLET

COLOR TEMPERATURE

Colors are classified as either warm or cool. Warm colors look vivid and energetic and seem to advance in a piece of art, while cool colors are seen as calm and soothing and appear to recede.

TINTS, TONES, AND SHADES

You can lighten, darken, and reduce the saturation of colors by mixing them with neutrals.

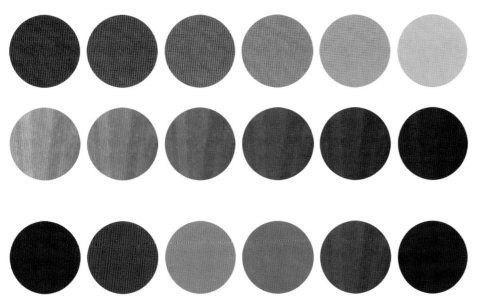

To lighten a color, creating a **tint**, add white until you've reached your desired lightness. To darken a color, creating a **shade**, add black until you've reached your desired darkness.

Create a range of **tones** by adding in small amounts of gray (mix equal parts black and white).

MIXING BROWN

There are countless shades of brown, and it is useful to know how to create some of them when drawing and painting kid-friendly subjects like trees and animals.

One way to mix brown is by combining all three of the primary colors. Another way is by mixing **complementary colors** (they sit directly opposite from each other on the color wheel) to create different hues of brown.

WHEN DRAWING WITH PEN OR PENCIL, LAYER THE COLORS OVER EACH OTHER TO CREATE NEW ONES. PAINT CAN BE MIXED TO CREATE A BEAUTIFUL RANGE OF COLORS.

ANIMALS

Let's start with something that all kids will ask grown-ups to draw at some point: animals! Knowing how to draw animals is a good skill to have if your youngster asks for help creating a picture of the family pet or the bird that frequents the feeder in your garden. And we can't forget wild animals too!

We'll begin with furry pets because their shapes are a bit easier to draw!

CATS & DOGS

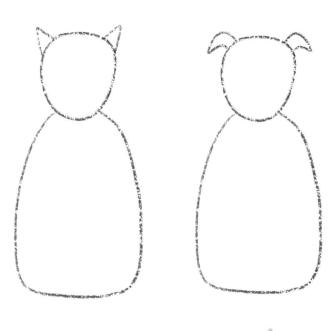

When drawing animals, I like to break them down into the simple shapes you see here. A cat or dog's body is an oval that's flat at the bottom; the head is a squat circle; and the ears are two little triangles.

Color in your shapes. With a darker color or a pencil, add the animal's facial features. Also draw in legs with rounded paws and little claws or toes.

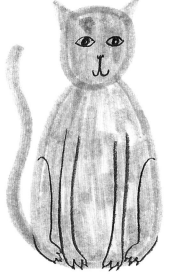
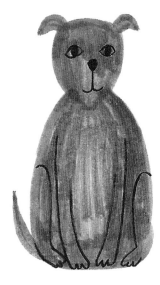

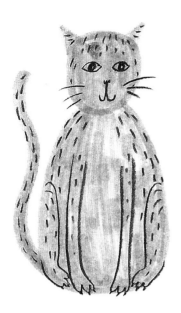
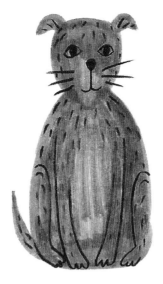

Add fur, keeping in mind the direction of hair growth. Make the lines around the face sparser, as an animal's hair is shorter there.

TO DRAW FUR AND WHISKERS, PRESS HARDER ON YOUR DRAWING TOOL AT THE BEGINNING OF THE STROKE AND LIFT THE TIP AT THE END.

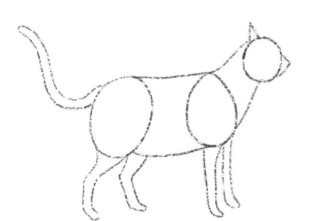
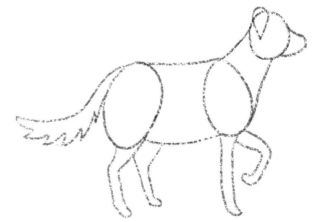

Follow the same basic principles when drawing animals from the side. Notice the large oval for the body and the smaller ovals for the shoulders, haunches, and head. The legs extend from the shoulders and haunches, thinning out at the bottom and bending slightly backwards.

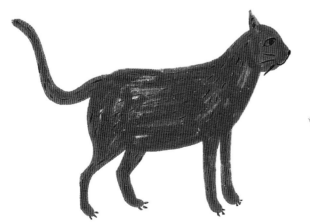
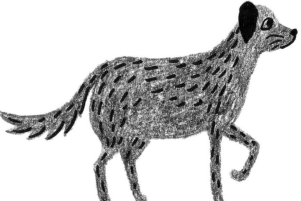

To draw an animal that's walking, bend its legs and vary their angles.

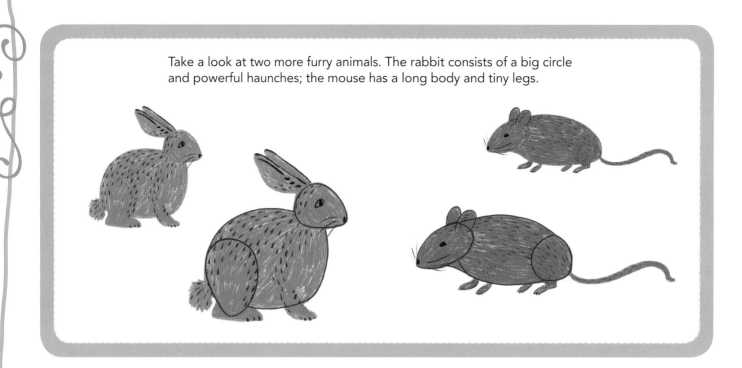

Take a look at two more furry animals. The rabbit consists of a big circle and powerful haunches; the mouse has a long body and tiny legs.

LARGE ANIMALS

With their sleek hair and muscular bodies, larger animals, such as horses and cows, can be more difficult to draw. You just have to be more accurate when placing your shapes. This may take some practice!

Use egg shapes and ovals to draw the larger parts of a horse. The neck curves downward, and the legs consist of curved and straight lines.

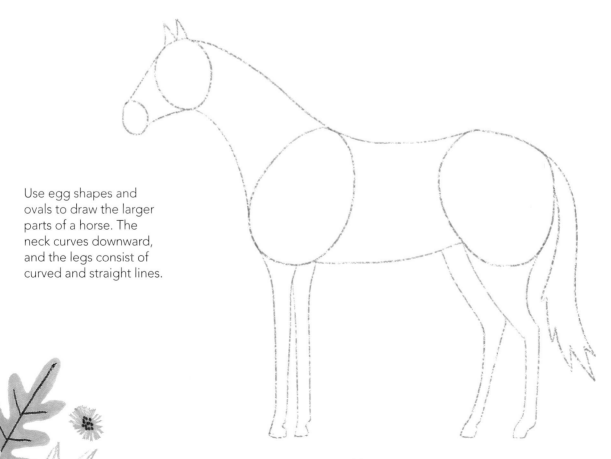

A cow has a similar structure, with slightly different shapes. Don't forget the udders!

WHEN DRAWING A MANE OR A TAIL, START WITH LONG, WAVY LINES AT THE TOP TO SHOW MOVEMENT IN THE HAIR.

Adding details is a lot of fun! You can add spots and markings or color in the animal by moving your drawing tool in the direction of hair growth. Draw round eyes and oval nostrils.

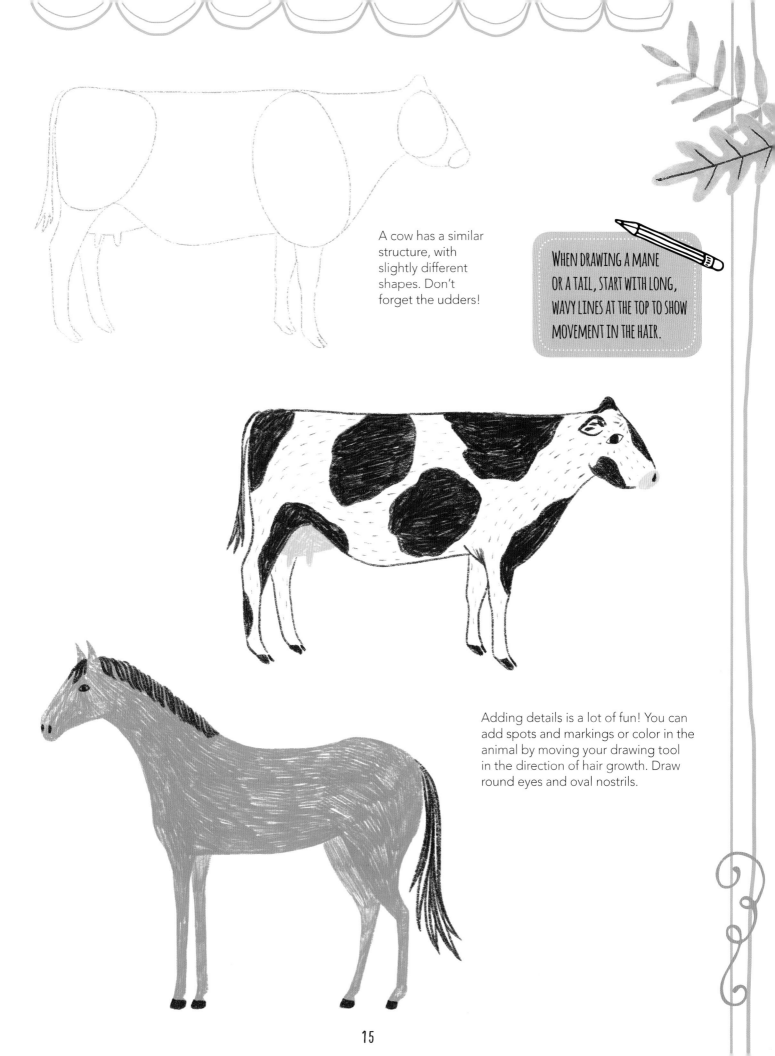

WILDLIFE

Once you have mastered an animal's basic shape, try creating more exotic versions of your cats, dogs, and horses!

Draw a cat! Then add stripes to make it a tiger, spots for a cheetah, or a fuzzy mane if it's a lion! Big cats have longer, sleeker bodies and thicker legs than domestic cats, so you can play around with the body structure here.

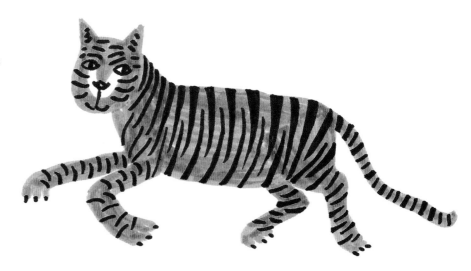

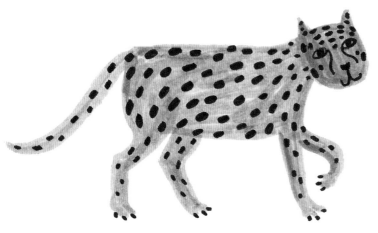

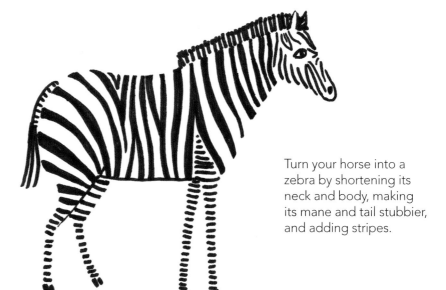

Turn your horse into a zebra by shortening its neck and body, making its mane and tail stubbier, and adding stripes.

Now try drawing a giraffe. You can use the same basic structure for any large, four-legged animal. Then slope the back, lengthen the neck, and create the giraffe's distinctive pattern.

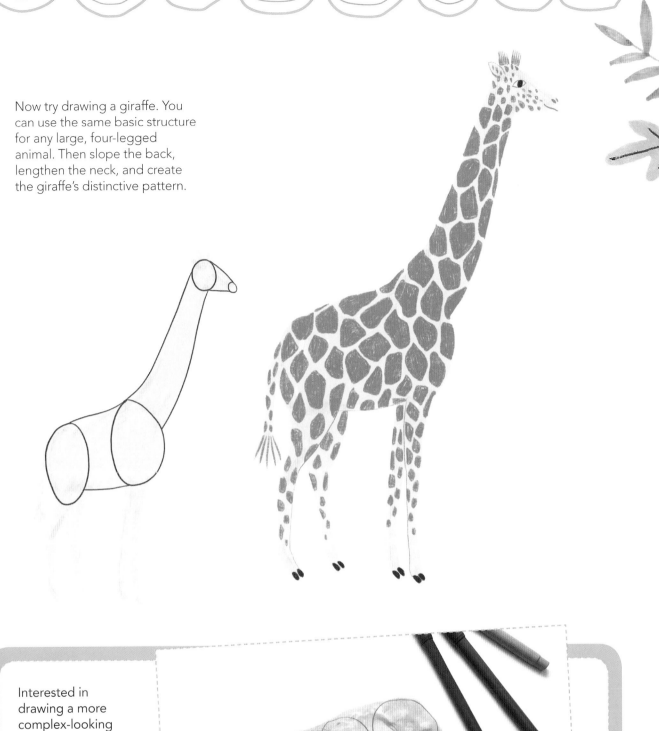

Interested in drawing a more complex-looking animal? Lay a sheet of tracing paper over a photo and find the main shapes within the animal's body. You will notice that most mammals share the same basic structure.

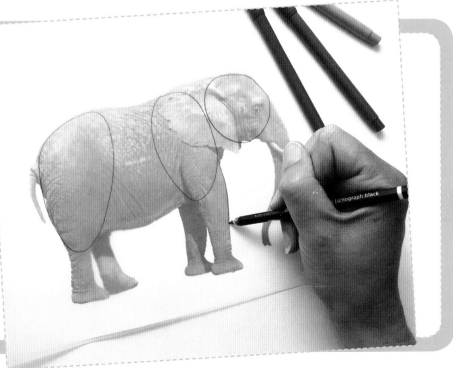

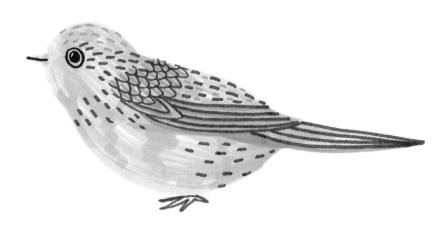

Birds are one of my favorite drawing subjects. Like the animals you already learned to draw, birds consist of a simple structure: an oval body; a small, round head; lines for the tail feathers and beak; and a neck if it's a waterbird or fowl.

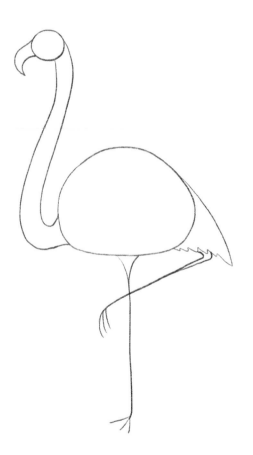

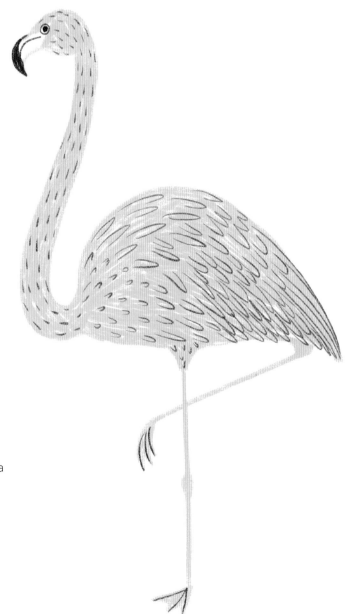

Depending on the type of bird and its position, the legs and claws will look different. A little bird on a branch will show just a few claws, while a flamingo will display long, spindly legs and big, webbed feet!

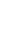

Use the structures here to draw birds, filling in the shapes and having fun with the feather patterns. Draw them semirealistically with curved lines, or go to town with crazy colors!

To draw a bird in flight, follow the same basic process. Instead of drawing folded wings, however, make a soft "S"-shaped line on each shoulder.

CRAZY CREATURES

This fun drawing and painting activity requires few materials and is a great way to fire up your child's imagination. It's a little like the age-old game of looking at clouds and guessing what they look like, but this time, you'll play with paint and pens!

TOOLS & MATERIALS

- Assorted paint colors
- Paintbrushes— and your fingertips!
- Sheets of paper or card stock
- Fineliner pens

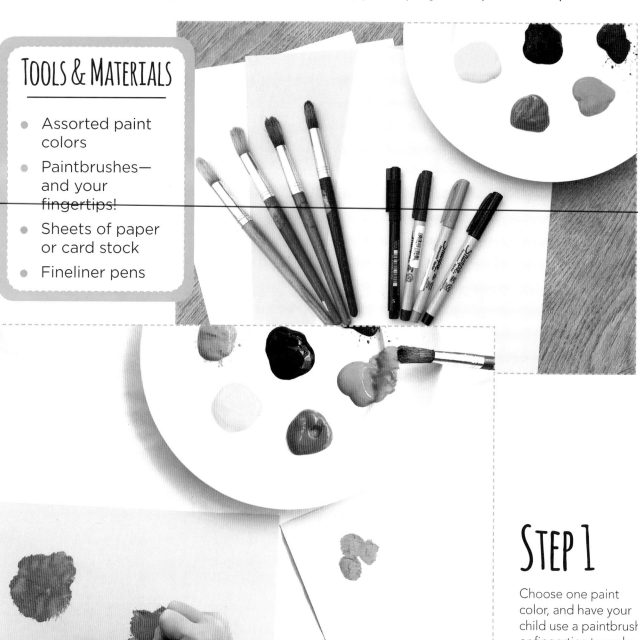

STEP 1

Choose one paint color, and have your child use a paintbrush or fingertips to make small blobs and shapes on a sheet of paper or card stock. Kids will love creating shapes of their own!

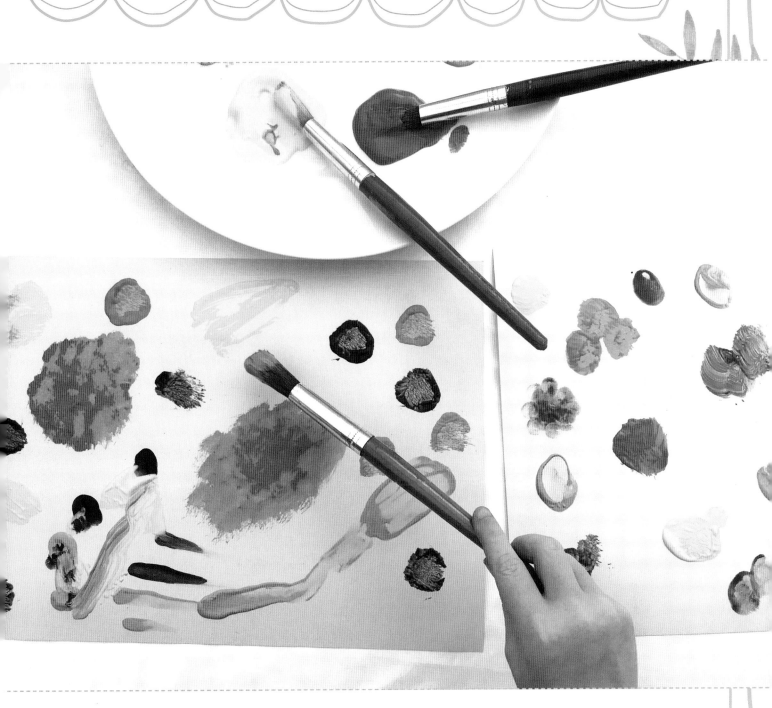

STEP 2

Continue making blobs across the page using different paint colors. Leave room around the blobs so that you can decorate them later.

MAKE DIFFERENT SHAPES: SOME CAN BE ROUND, AND OTHERS CAN BE SHAPED LIKE OVALS OR EVEN SNAKES!

Step 3

Let the blobs dry. Meanwhile, look at your shapes and think about the creatures they can become. Did the bristles of your paintbrush leave marks that look like hair? Do the shapes already resemble animals or monsters? Ask for your kids' help here; children have vivid imaginations and will love this step!

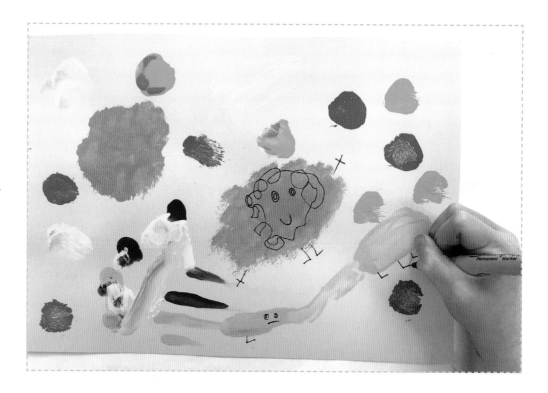

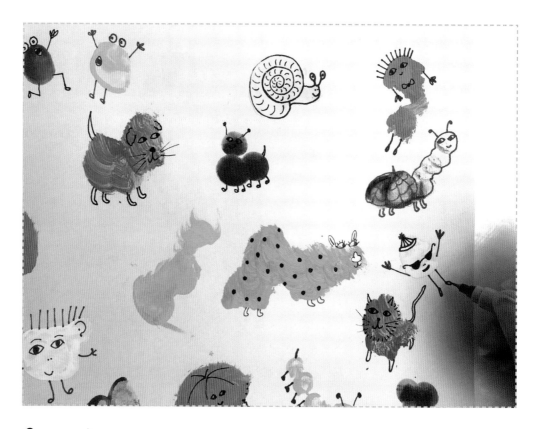

Step 4

Now put that imagination to work and use fineliner pens to add eyes, legs, feet, tails, hair, and more to create funny little creatures.

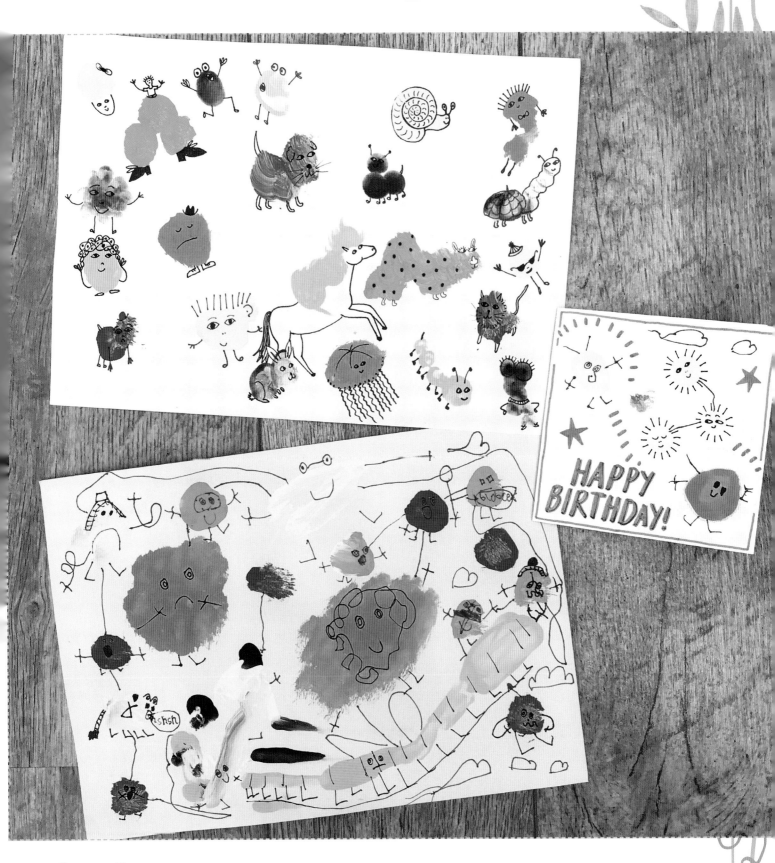

STEP 5

Finish transforming all of the blobs and shapes into crazy creatures. Now you and your child have a fun piece of art that you can display in your home, or you can cut out some of the creatures and glue them onto a card as a gift to a friend!

23

On the Move

When learning to draw cars and moving machines, one of my top tips is to practice by drawing toys. Toys often lack substantive details, allowing you to focus on the item that you're drawing rather than getting caught up in trying to draw it too realistically. This will give you an effective image to which you can add details later if you wish.

CARS & BUSES

Begin by drawing a side view of a vehicle. Start with the wheels. Pay attention to their size relative to the rest of the car. In this car, the wheels are approximately 2½ wheel widths apart. I like to mark where I'll place my wheels before adding them. You can gauge where the body of the car curves relative to the wheels using imaginary vertical lines, which I've marked here.

Then, using the car's body color, outline the rest of the car, moving from left to right. Now color it in and add windows, doors, and lights using a darker color.

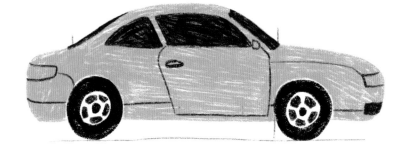

Next, draw a car from the three-quarters perspective. The process is generally the same, but keep in mind that the wheels will look like ovals and should be at a slight angle. Angle the body of the car too.

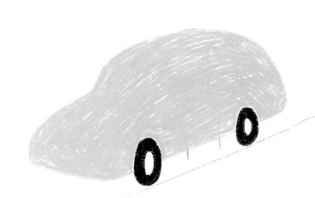

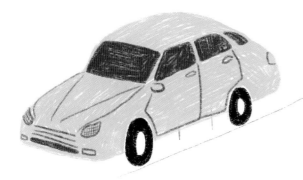

I LIKE TO ADD COLOR RIGHT AWAY, SO IF I MAKE A MISTAKE, I CAN COVER IT UP BY ADDING MORE COLOR OR INCREASING THE SIZE OF MY DRAWING.

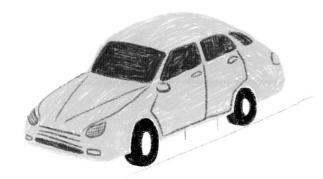

Follow the same drawing principles to create just about any other type of vehicle.

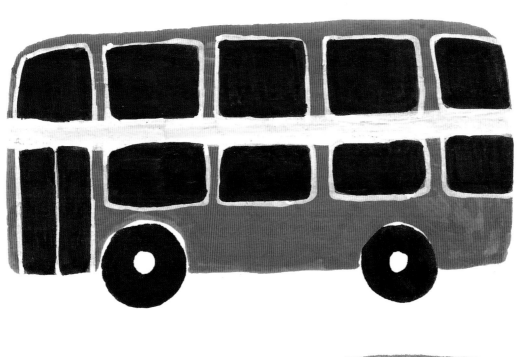

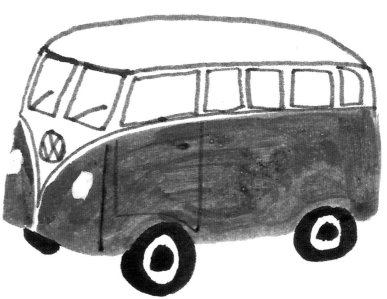

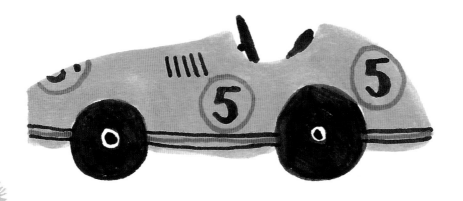

BOATS

When drawing or painting boats, keep in mind that they float *in* the water, not on top of it, so you won't see the bottom half of the vessel in your artwork.

I like to start by drawing the water, and then I work my way up through the hull. Lastly, depending on the type of boat, I draw the cabin or sails on top.

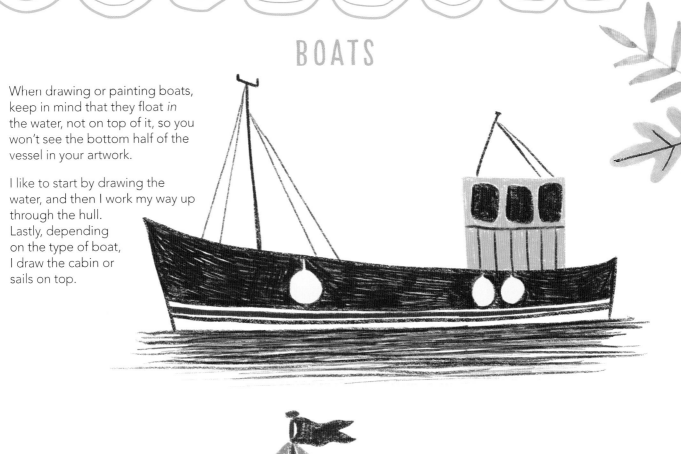

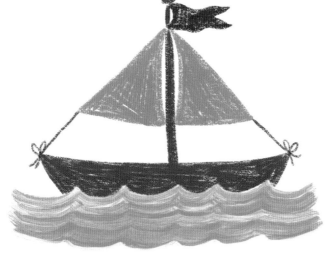

To draw a sailboat, lightly sketch in the mast; then draw the sails before finalizing the mast. This will help you place the sails without having to erase areas of the mast.

DON'T FORGET TO ADD DETAILS LIKE PORTHOLES, FLOTATION DEVICES, AND OARS TO MAKE YOUR DRAWING COME TO LIFE.

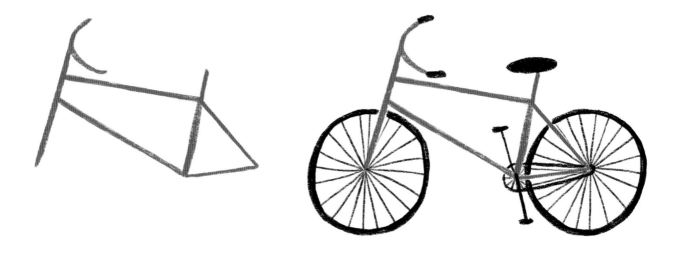

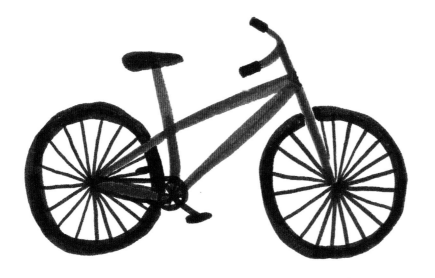

I draw bikes starting with the frame. Using a light color for the frame makes it easier to add darker details on top. Unless you have incredible freehand-drawing skills, creating bike wheels will never be easy—just make sure to take your time and don't draw over the frame. Embrace the hand-drawn quality of your wheels, and space out the spokes evenly.

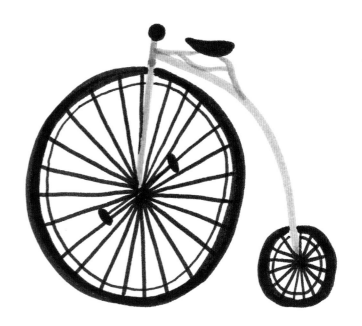

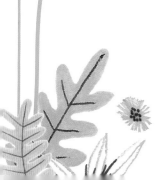

HEAVY-DUTY VEHICLES & TRAINS

As with other vehicles, I like to draw heavy machinery starting with the wheels and working my way up. Don't forget to leave room for details, such as a blade if you're drawing a bulldozer or a shovel if it's a digger.

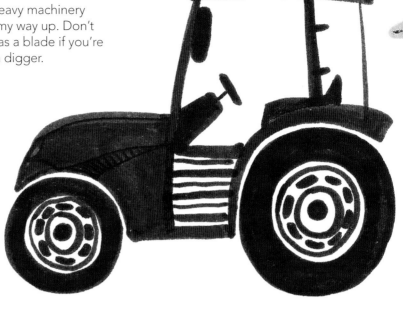

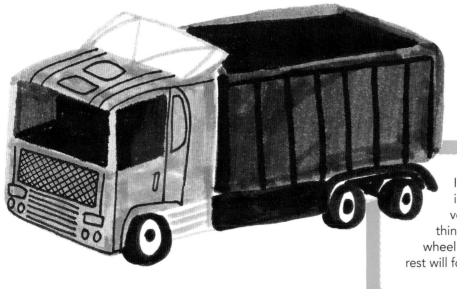

I've only included very basic instructions for drawing vehicles. The most important thing to remember is getting the wheel sizing and spacing right. The rest will follow more easily.

Trains can be drawn the same way, or you can draw the individual cars first, and then add little wheels and train tracks afterward.

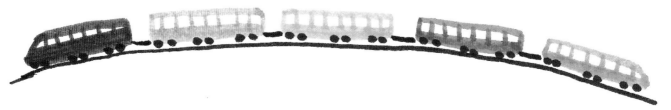

29

POP-UP SCENE

Kids will love seeing their drawings come to life in this three-dimensional art project. Add or subtract elements to make it as simple or complex as you wish.

TOOLS & MATERIALS

- Light-colored sheet of thick paper (plus a spare sheet in case you make a mistake!)
- Old cereal box, cut open to form a flat surface
- Pencil
- Scissors
- Glue stick
- Markers or paints and paintbrushes

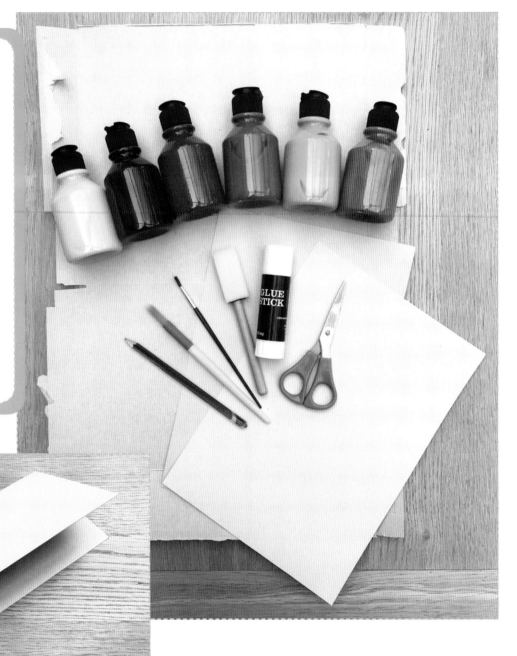

STEP 1

Fold the thick paper in half lengthwise, and then unfold it.

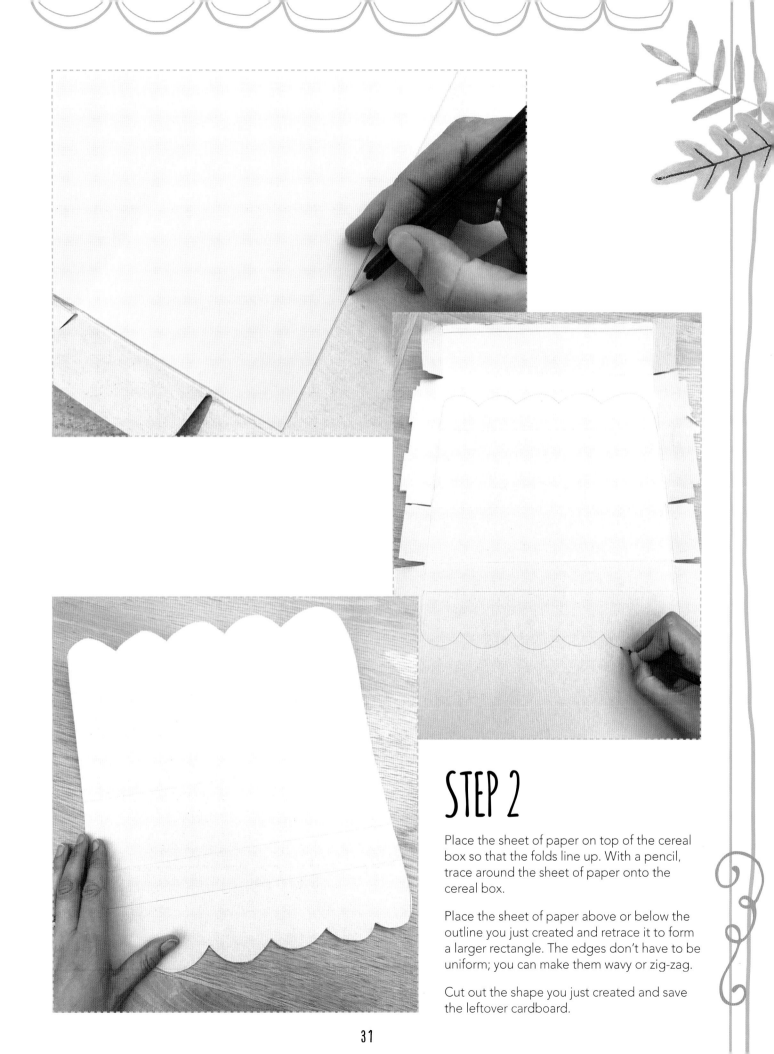

STEP 2

Place the sheet of paper on top of the cereal box so that the folds line up. With a pencil, trace around the sheet of paper onto the cereal box.

Place the sheet of paper above or below the outline you just created and retrace it to form a larger rectangle. The edges don't have to be uniform; you can make them wavy or zig-zag.

Cut out the shape you just created and save the leftover cardboard.

STEP 3

Fold the sheet of paper, and make two 3-inch cuts to the folded side. Then make two more pairs of cuts: two 2-inch cuts and two 1-inch cuts.

Unfold the sheet, and you should have three strips of different lengths across the center of the sheet.

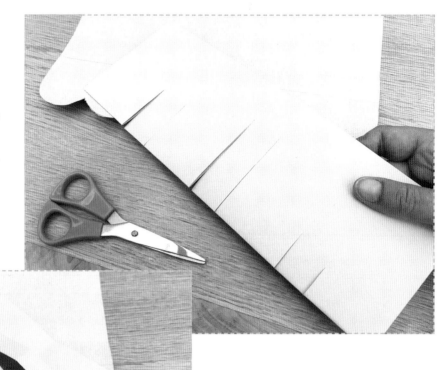

STEP 4

Fold the strips so that they stick out from the sheet of paper in a square shape.

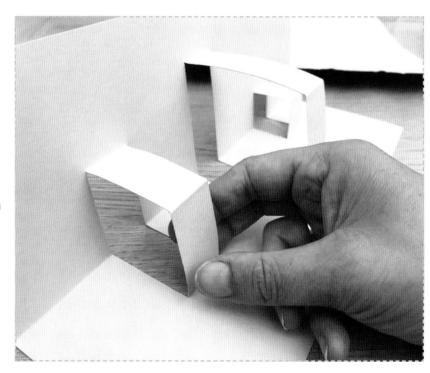

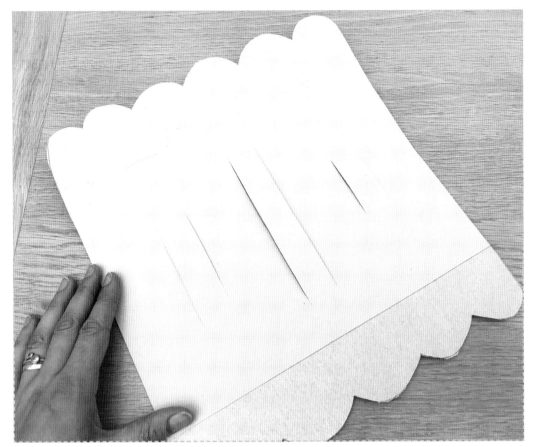

STEP 5

Place the cut paper on top of the cereal box, and align their folds. Glue the paper onto the cereal box, without applying glue to the folds.

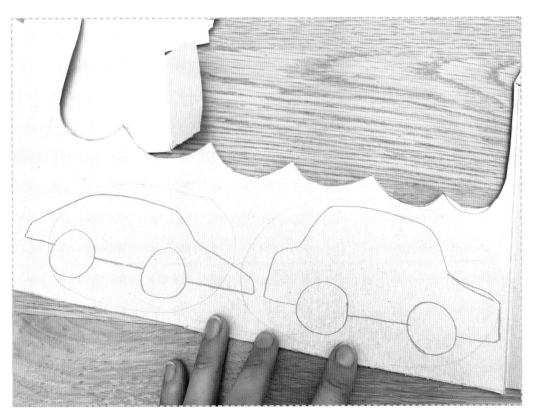

STEP 6

Using your leftover cardboard, sketch the outlines of three vehicles. You will need to attach each car to one of the folded strips, so make sure the vehicles are large enough to cover the strips.

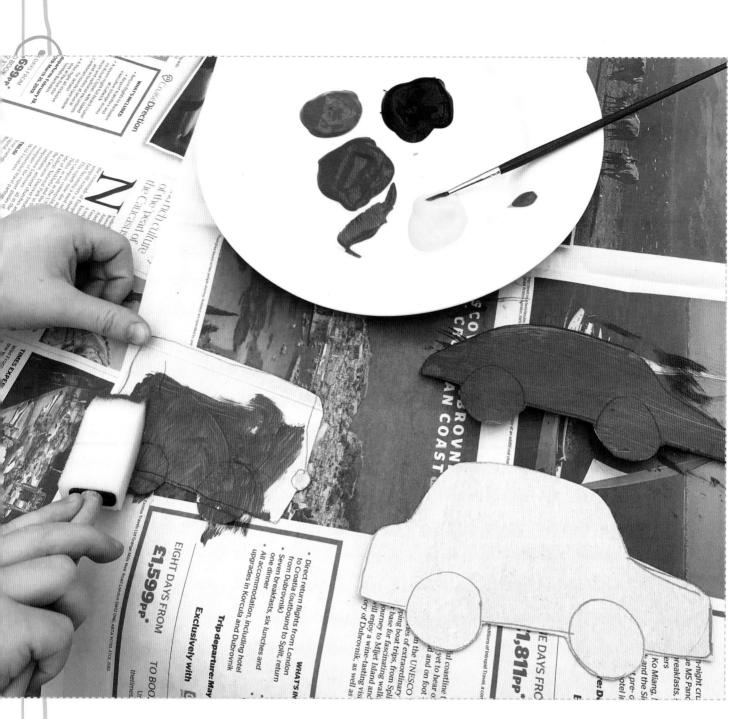

STEP 7

Cut out the vehicles and apply a base coat of paint to each one. Let them dry.

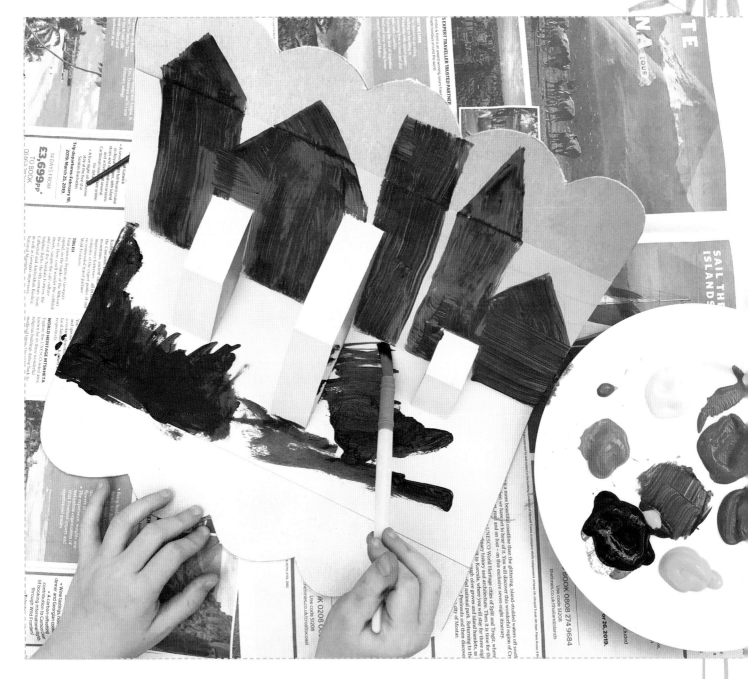

STEP 8

Now, paint the background of your pop-up scene. My kids and I painted buildings, a road, and some bushes in the foreground.

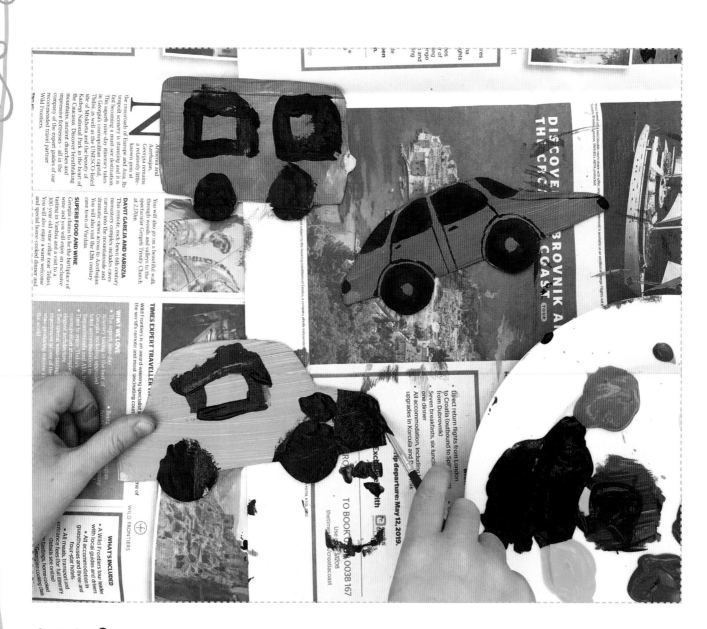

STEP 9

The vehicles should be dry by now. Add details to them, such as windows, wheels, and lights.

STEP 10

Arrange the cars on the strips and glue them down to finish your pop-up scene!

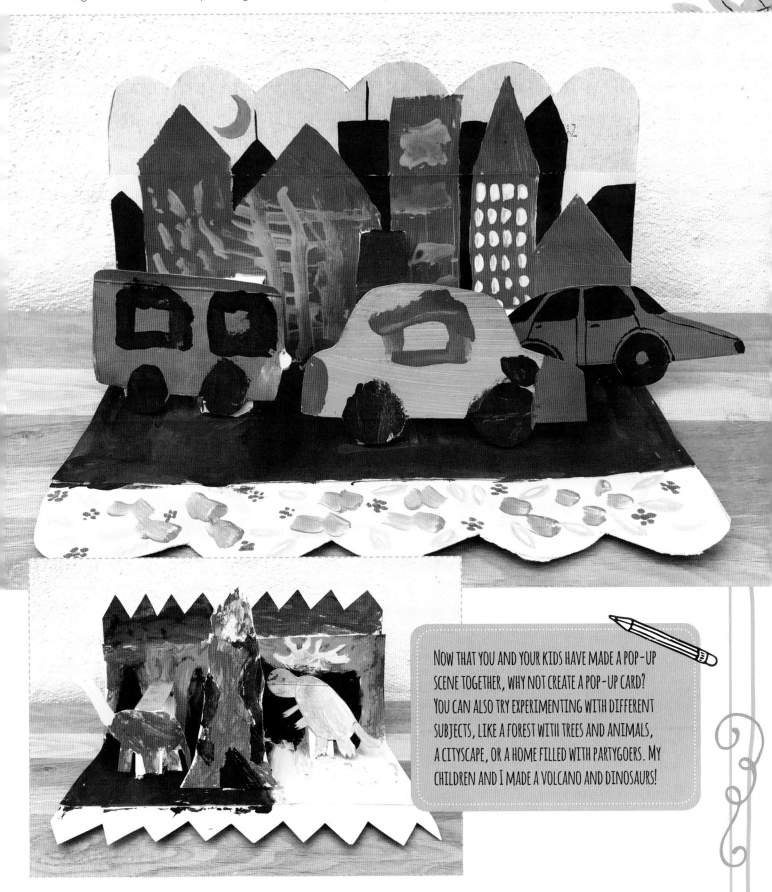

Now that you and your kids have made a pop-up scene together, why not create a pop-up card? You can also try experimenting with different subjects, like a forest with trees and animals, a cityscape, or a home filled with partygoers. My children and I made a volcano and dinosaurs!

PEOPLE

Now, let's move on to drawing people! Over the years, I've lost count of how many times my kids have asked me to draw our family or scenes of people doing different activities. Young children love it when they can spot a resemblance in art, so it's even better if you can add a likeness and an expression to the faces you draw.

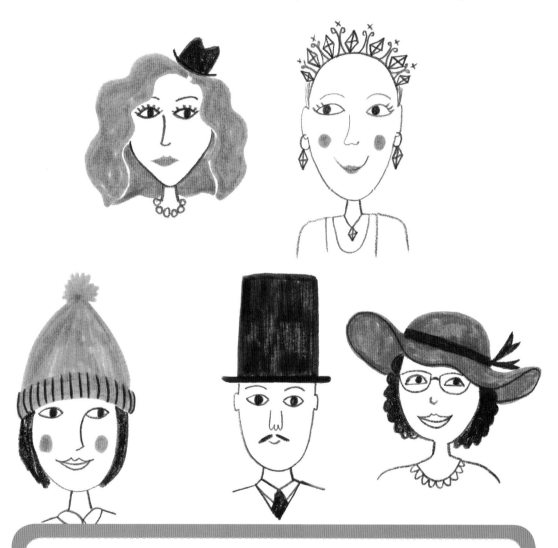

IT'S ALL IN THE FACE

When depicting people, one of my favorite ways to warm up is by drawing many different faces. This way, I don't have to worry about getting the body anatomically correct, but I can still come up with a variety of characters and have fun with their facial expressions, hairdos, and accessories!

On a piece of paper, use a pencil to draw an oval for the head, with a little neck sticking out of the bottom.

Lightly draw a horizontal line across the center of the oval. In an anatomically correct image, this is where the eyes will go; add them now. Also draw in the eyebrows, nose, and a smiling mouth.

Add more features, like ears and hair, and you've drawn a simple face!

Now let's draw a woman's face! Draw the head and the neck; then pencil in a line across the center of the face. Add outlines for the eyes, but this time, draw the pupils in one corner of each eye so that the subject appears to be looking to one side.

Add eyebrows and a nose.

Finally, add ears, a surprised-looking mouth, and hair!

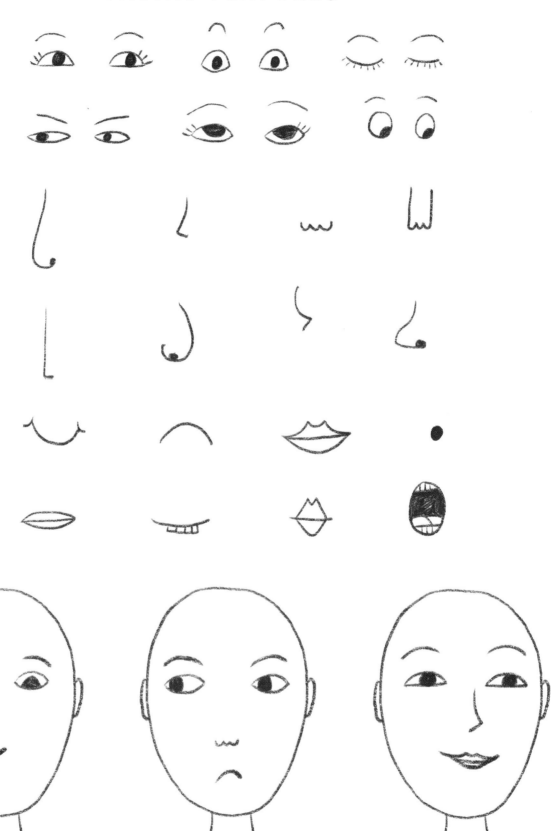

Play around with drawing different facial features, such as eyes, eyebrows, noses, and mouths.

Notice how varying the features even slightly can change the facial expression.

ADDING COLOR

 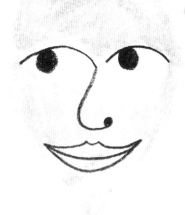

It's time to add color. I drew these faces by outlining the heads and eyes in marker and then coloring in the rest. I added the other facial features using a pencil.

PROFILES

 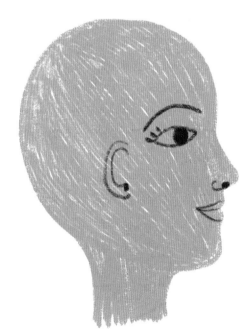

Drawing a head from the side is kind of like drawing half a face. Try drawing an inverted egg, with the narrowest point being the chin. Then add the facial features.

HAIRSTYLES

Now let's add hair! Varying the hairstyle really changes a person's appearance. Feel free to go crazy with color too! Here are some examples of hairstyles, as well as tips for drawing them.

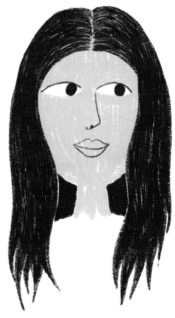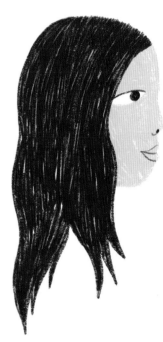

To draw long hair, start at the top of the head, and form a line where you want the hair to lie around the face. Draw another line at the back of the head, and then fill in the rest of the hair with separate strokes. Taper the strokes at the bottom.

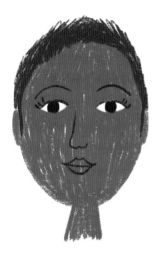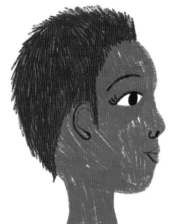

Use short, back-and-forth strokes to draw a cropped hairstyle. Make sure the hair moves away from the hairline, not across it.

Drawing spiky hair is similar to drawing cropped hair, but taper the strokes into large spikes at the top, angling the strokes slightly.

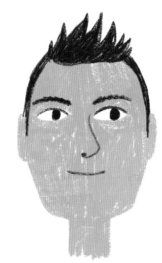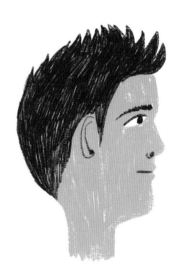

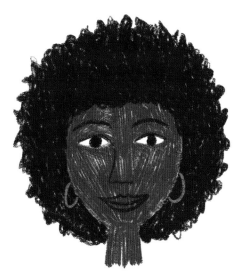
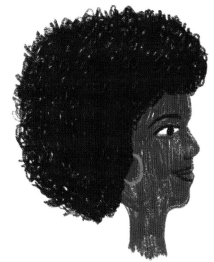

To create curls, make tiny, scribbled circles, changing direction often. Then use a lighter color to shade over anywhere that the paper shows through.

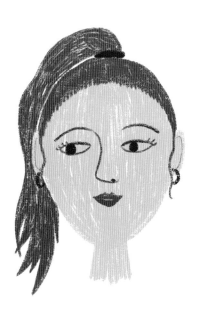
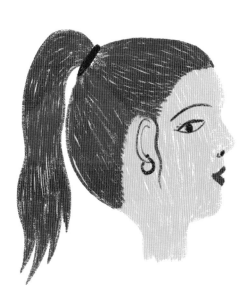

Ponytails are difficult to draw from the front, so I like to make them swing to one side. Stroke from the front of the head to the back, and taper the ends to give the hair movement.

To create a bob with bangs, draw the hair moving away from the part. The front should frame the face.

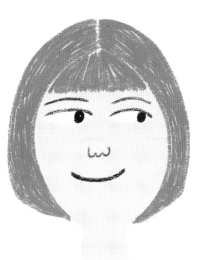
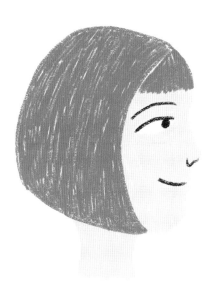

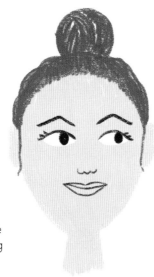

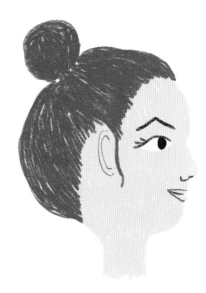

Draw a bun the same way you drew a ponytail. Obscure the bottom of the circle behind the back of the head when drawing a bun from the front.

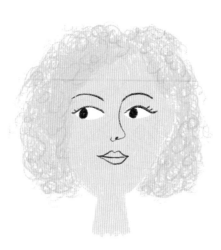

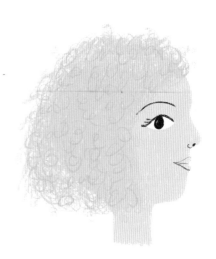

To draw longer curly hair, make random scribbles until you've filled in the whole head. Lightly shade over the hair with the same motion to eliminate any background color. Use a darker shade to add loose, defining curls on top.

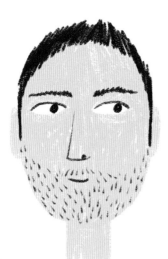

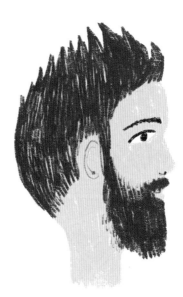

Stubble and beards have the same basic shape, but you'll use dots for stubble and short, quick, back-and-forth strokes for a beard.

PRACTICE HERE!

Rotate this book; then use the areas below to practice what you've learned. Invite your child to practice on one side while you practice on the other.

ACCESSORIES

Accessories are really fun to draw!
Here are a few tips:

- It's easier to add a hat first, before drawing the hair underneath it.
- To draw glasses, start with the frames, and then add a little arch for the bridge and lines at the sides.
- Color in eyeglasses to turn them into sunglasses.

BODIES

My kids love seeing full-body drawings too! Let's look at some simplified outlines of bodies that will help you get the proportions right.

As a general rule of thumb, young children are approximately 4 heads high, older children are 6 heads high, and adults are 8 heads high.

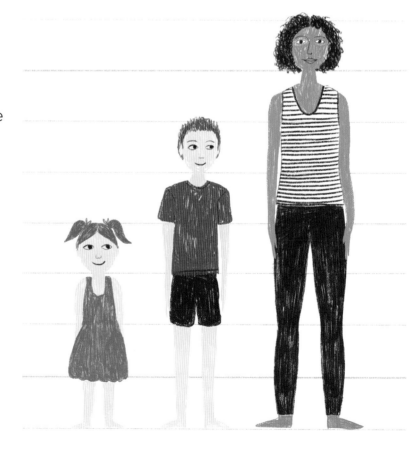

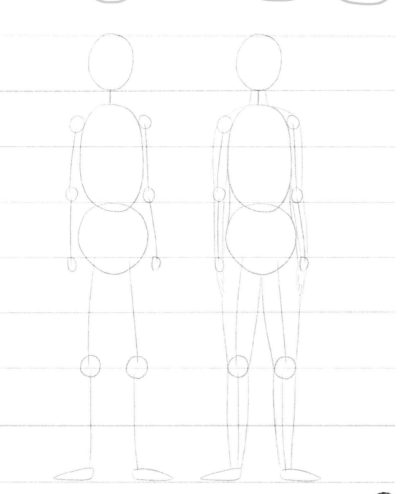

Similar to drawing an animal (see pages 12-19), you can use ovals and circles to create a simplified version of a human's body. The fingertips should fall about 3½ head lengths from the ground.

After you've outlined the basic shapes of the body, fill in the limbs.

Once you get the hang of drawing a figure, you and your child can personalize your people! Maybe you want to use one of the faces you already drew and add features and hair. Clothes are fun to draw too!

The last step is to color everything in. Move your strokes downward on the limbs to show form.

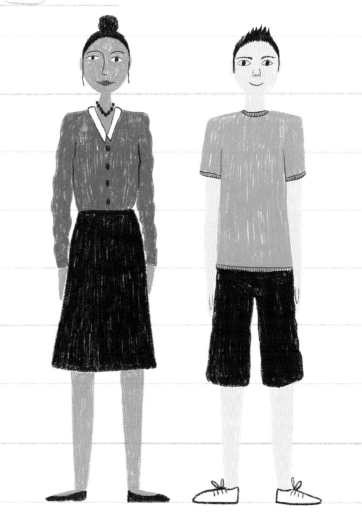

Paper Doll Garland

If you like drawing people and creating outfits, this project will be right up your alley! This classic cutting and drawing activity is really fun to do with a little one's help. Try making up stories and giving each doll a name and a personality as you draw and color.

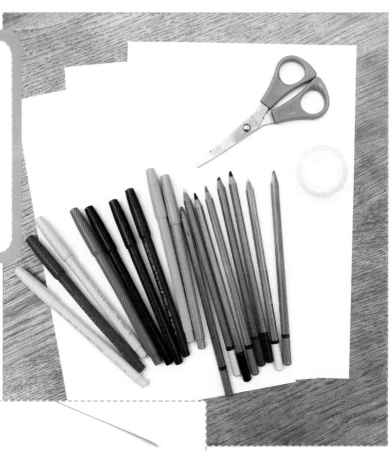

Tools & Materials

- 3 sheets of paper
- Scissors
- Tape
- 2 paper clips
- Colored pencils and markers

STEP 1

Tape the short ends of your sheets of paper together to create one long sheet, without overlapping the edges.

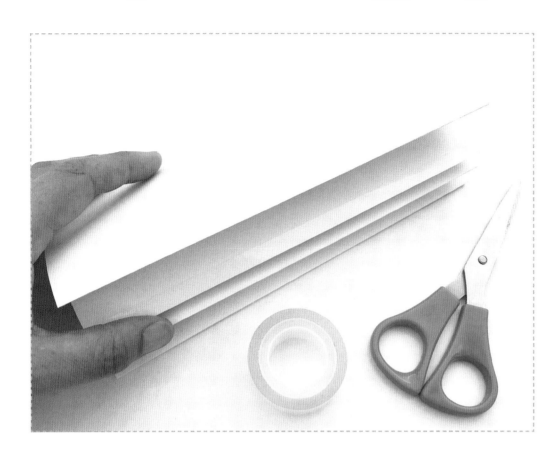

STEP 2

Fold the paper concertina-style so that each sheet is divided into three and you end up with nine panels (you'll make eight folds). Try to fold the paper so that the tape runs on the outside of the fold.

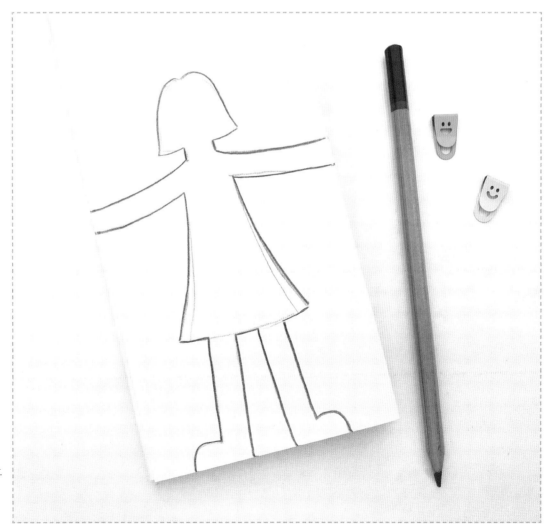

STEP 3

Keep the paper folded and draw a doll on the top panel, making sure that the arms extend to the edges of the paper.

STEP 4

Use a paper clip to hold together the top and bottom edges of the folded paper.

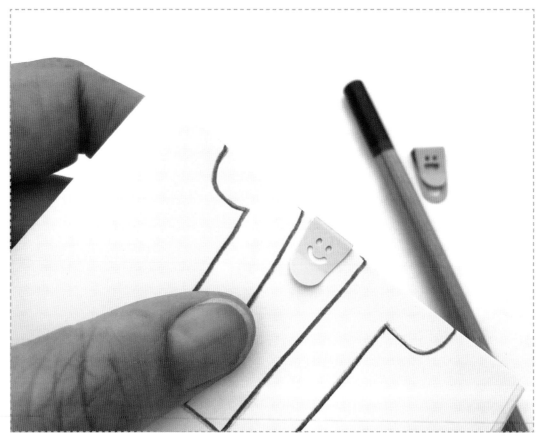

STEP 5

It's time to cut out your doll! Don't forget to cut to the edges of the paper so that the dolls will stay attached to one another.

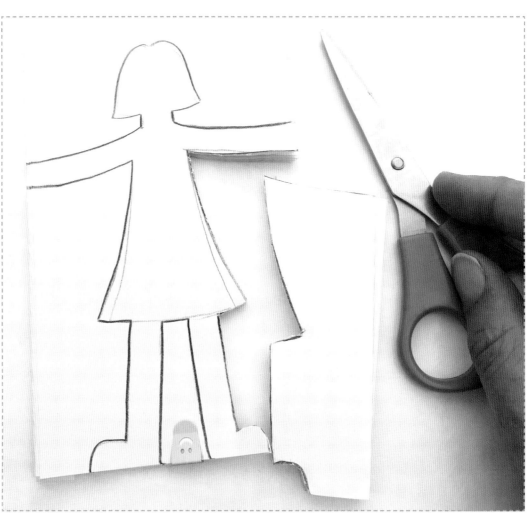

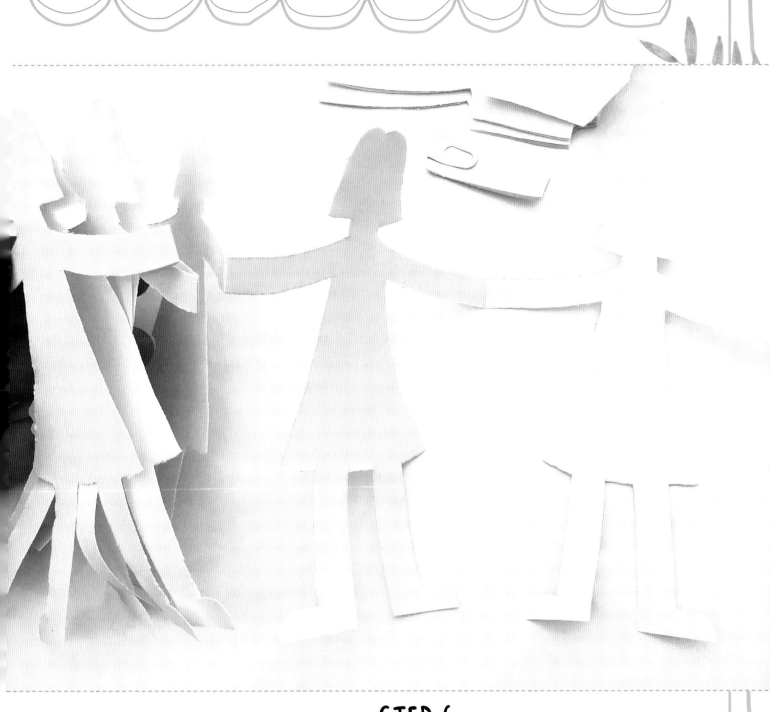

STEP 6

Carefully unfold your cut-out dolls and flatten them. If you folded the paper correctly, the taped edges and any pencil marks will appear on the backs of the dolls.

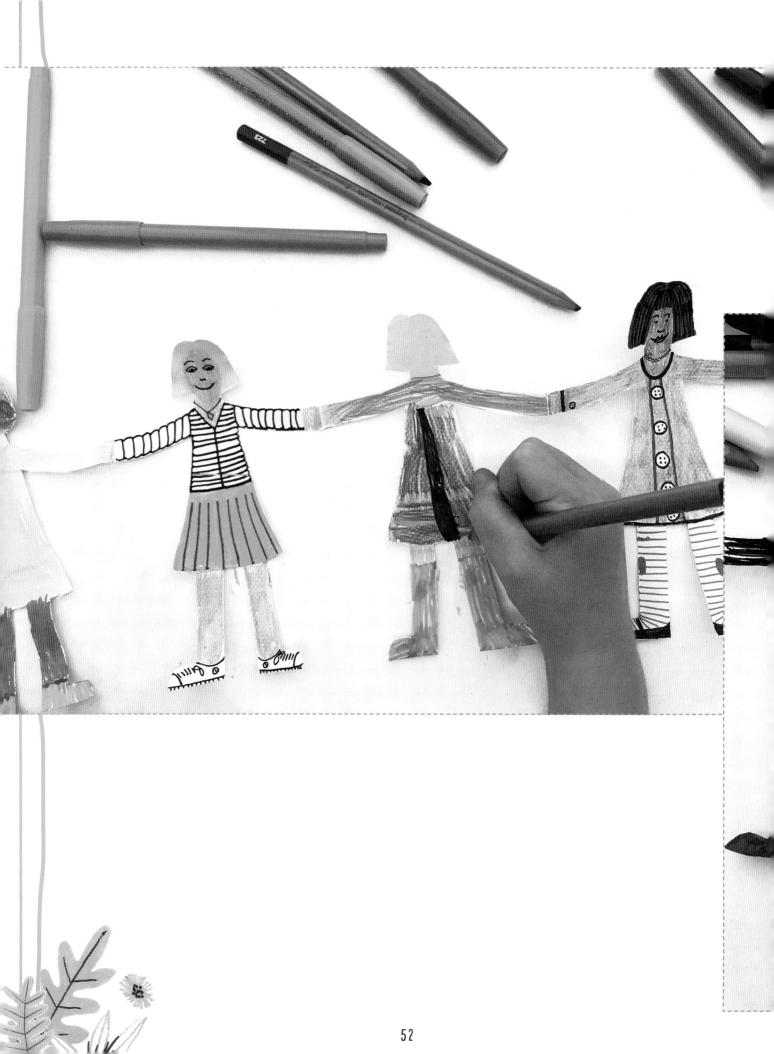

STEP 7

Start drawing! Play around with making up different outfits and facial expressions for the dolls. My kids and I like to add little buttons, necklaces, and shoelaces too!

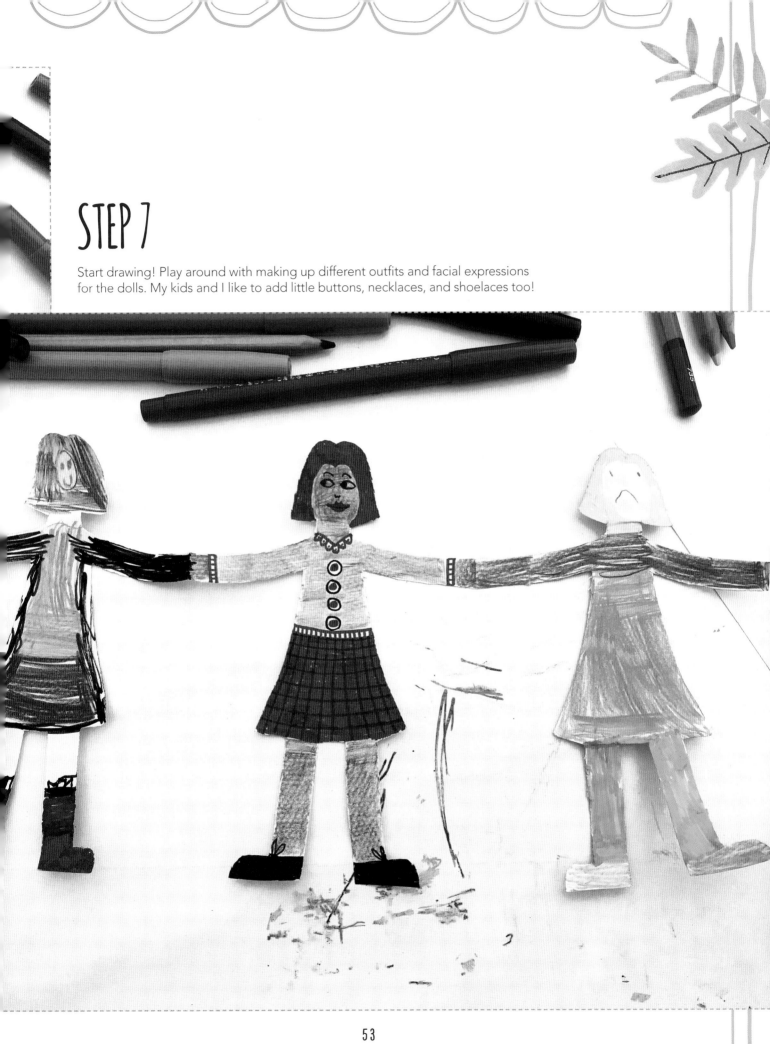

STEP 8

Once you and your kids have finished decorating your doll garland, hang it somewhere that you all can admire it!

Next time you want to create a paper doll garland, try creating a doll of a different shape. Leave off the skirt to make a chain of pants-wearing people, or use scissors to add variety to some of the outfits and hairstyles. You and your little ones will have a wonderful time making your own fashion parade!

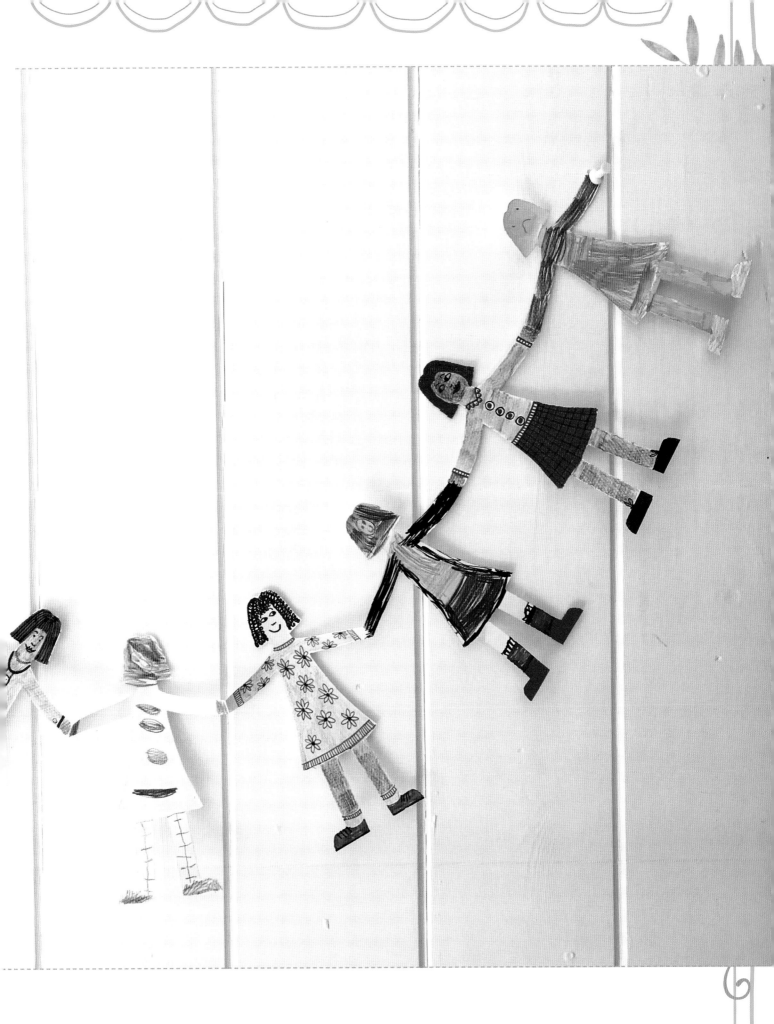

Leaves, Trees, and Flowers

Flowers and leaves come in beautiful shapes and sizes; they can be used to decorate many types of artwork, such as borders, patterns, gardens, and home scenes. A simple floral bouquet drawing makes a sweet gift, and leaves arranged into patterns are great for embellishing gift wrap and tags. Combine those leaves into a larger shape to draw a gorgeous tree!

LEAVES

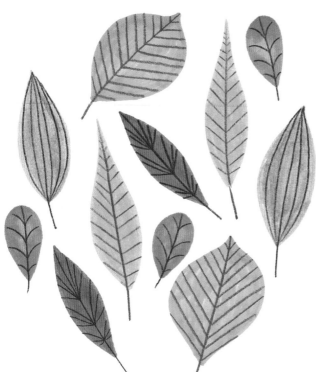

Leaves have one thing in common: a central vein. Here are a few basic leaves with different shapes and vein styles.

These leaves and fronds may look more complicated, but breaking them down into basic shapes makes them easy to draw. Best of all, they add an element of fun!

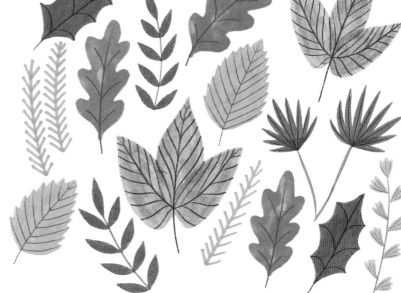

PRACTICE HERE!

Draw some leaves with veins. Make them as simple or as complicated as you'd like! Use lighter colors for the leaves and darker colors for the veins. Rotate the book so you and your kids can practice together side by side!

FLOWERS

Flowers come in an array of colors, shapes, leaf formations, and sizes—and they are simply beautiful! Some of the easiest flowers to draw are daisies and sunflowers. They feature just a puff at the center for the stamen, seeds, and petals all around.

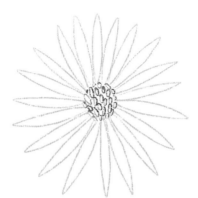

Start by drawing the center of the flower using a series of small circles or dots.

With another color, draw long, narrow petals that end in a soft point.

Color in the petals, and add a stem!

You can also foreshorten the shape of the flower to draw it from the side. Draw the center of the flower as a dome; then add a petal on each side.

Draw the rest of the petals, gradually shortening them as you reach the halfway point between the first two petals and lengthening them as you reach the other side.

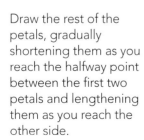

Add the rest of the petals and draw in the stem.

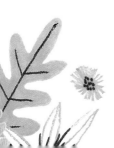

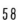

Here are some more floral shapes that you may want to practice drawing. I combined them with the leaves shown on page 56. Some of them look more realistic, whereas others feature wacky colors. That's part of the fun of drawing flowers: You can personalize them however you want!

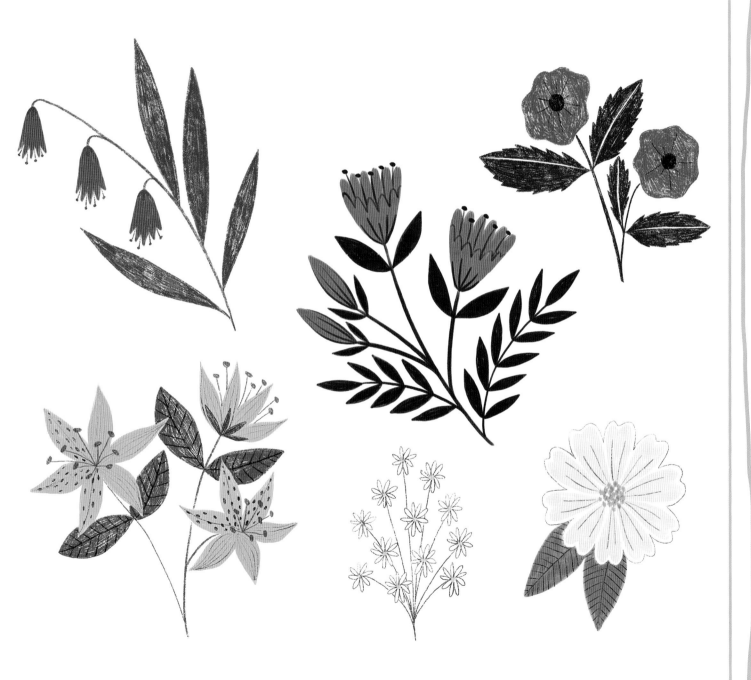

TREES

Trees are an important element of your drawing-skills toolkit. Once you learn to draw trees, you'll be able to create entire forests and woodlands, which are popular subjects for kids! Trees can also be used to soften and add life to an urban scene.

Use light gray to form the treetop using swirling, scribbling marks—also called "scumbling."

Using quick marks and scumbling, add light green, allowing some of the base gray color to peek through. Concentrate your marks where you want the leaves to appear densest. Add a medium-green layer on top.

With a dark shade of green, add dots to create shadows on the densest leaves.

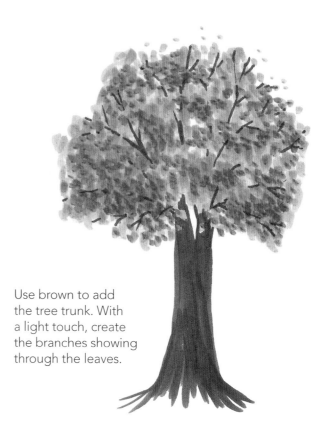

Use brown to add the tree trunk. With a light touch, create the branches showing through the leaves.

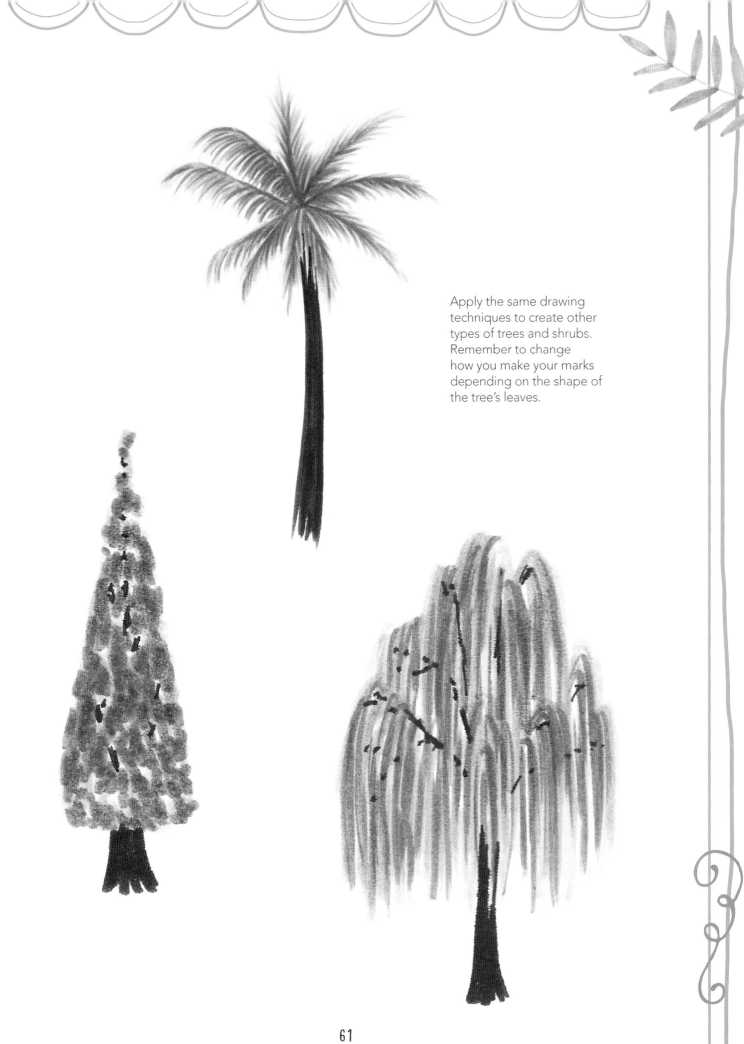

Apply the same drawing
techniques to create other
types of trees and shrubs.
Remember to change
how you make your marks
depending on the shape of
the tree's leaves.

Leaf Rubbing Tree

Leaf rubbings are a fun, creative activity for kids. From gathering leaves in the garden to turning leaf rubbings into a work of art, you'll explore nature at every step!

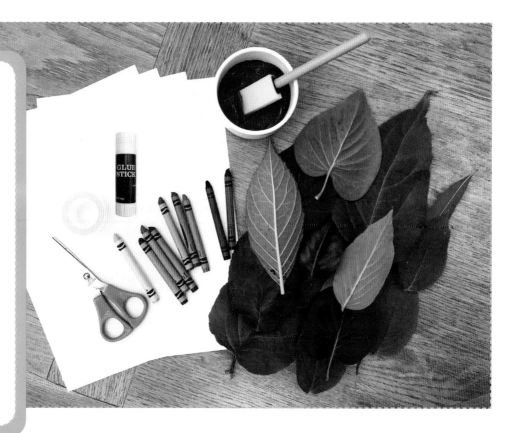

Tools & Materials

- Tape
- Several sheets of 8Đ" x 11" printer paper in white or pastel colors
- Paint
- Paintbrush or sponge
- Leaves from various trees
- Crayons
- Scissors
- Glue

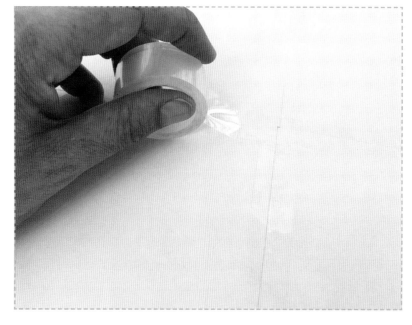

STEP 1

Tape together about 6 to 10 sheets of paper to make one large piece.

STEP 2

Turn over the large sheet of paper so that the tape is on the back. Paint a tree trunk in the center.

OUTLINE THE TREE TRUNK WITH PAINT, AND THEN HAVE YOUR CHILD FILL IT IN WITH COLOR!

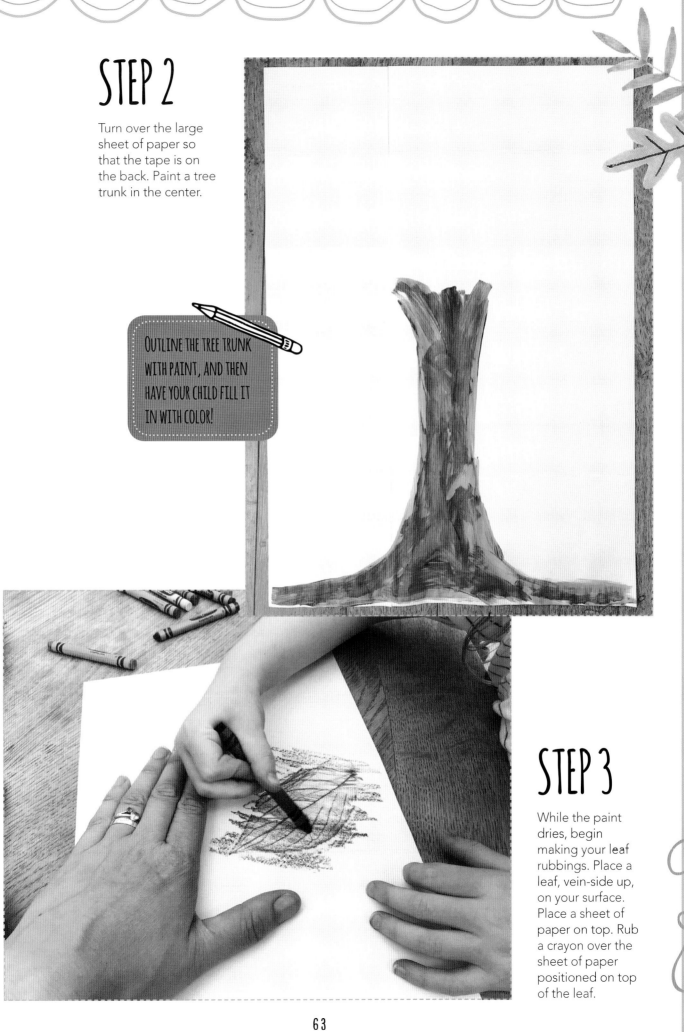

STEP 3

While the paint dries, begin making your leaf rubbings. Place a leaf, vein-side up, on your surface. Place a sheet of paper on top. Rub a crayon over the sheet of paper positioned on top of the leaf.

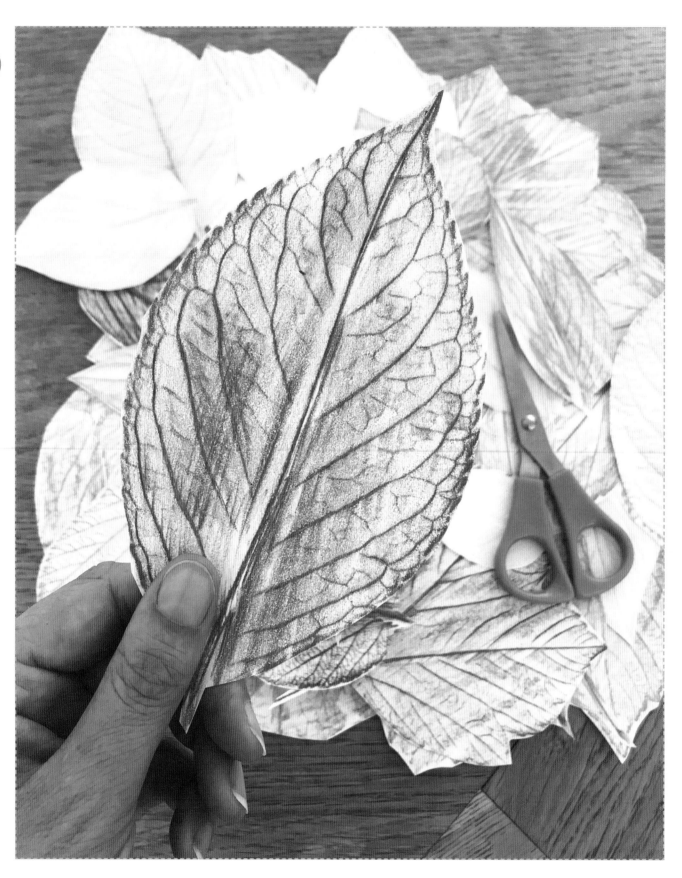

STEP 4

Continue using different crayon colors to make about 40 to 50 leaves for your tree.
Cut out the leaves.

STEP 5

Arrange the leaves around the tree trunk, and glue them down. It may work best to start by placing the smaller leaves on the outside and the larger leaves at the center.

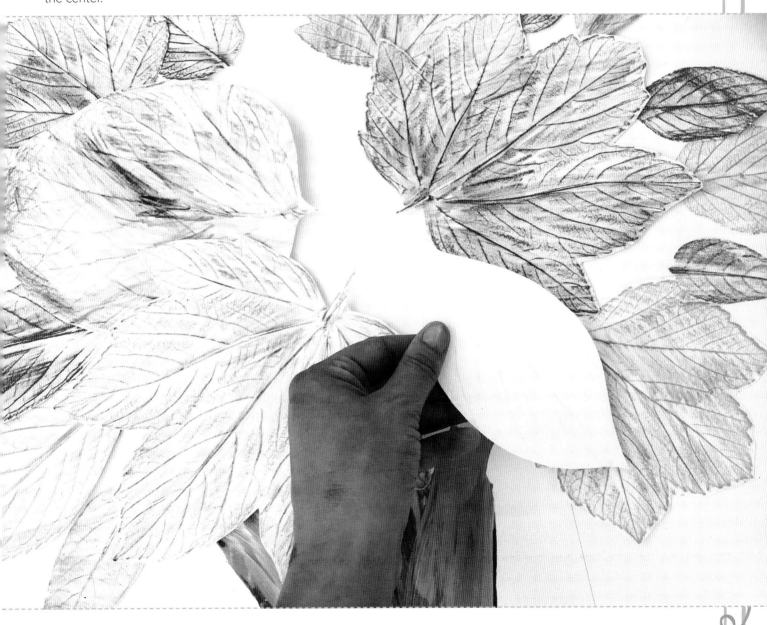

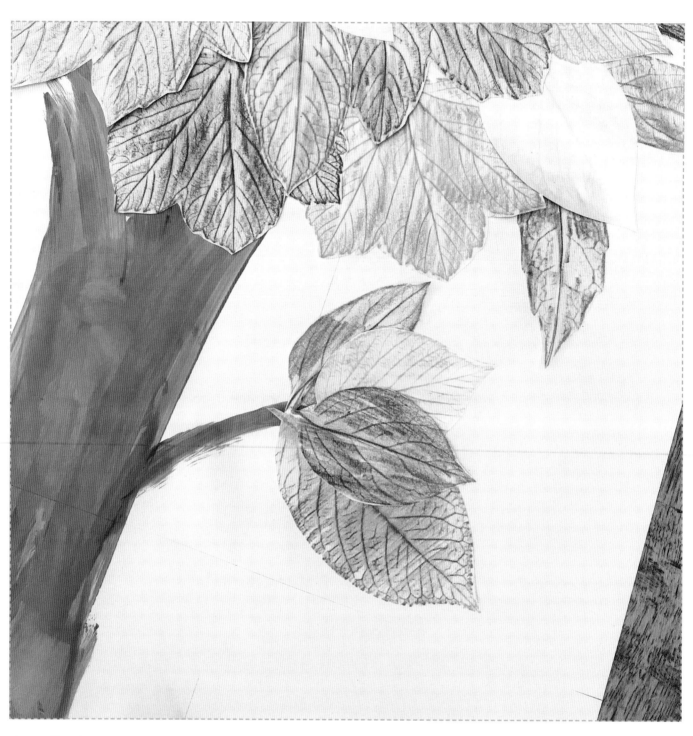

STEP 6

If you have any remaining leaves, add small branches
to your tree and glue on the extra leaves.

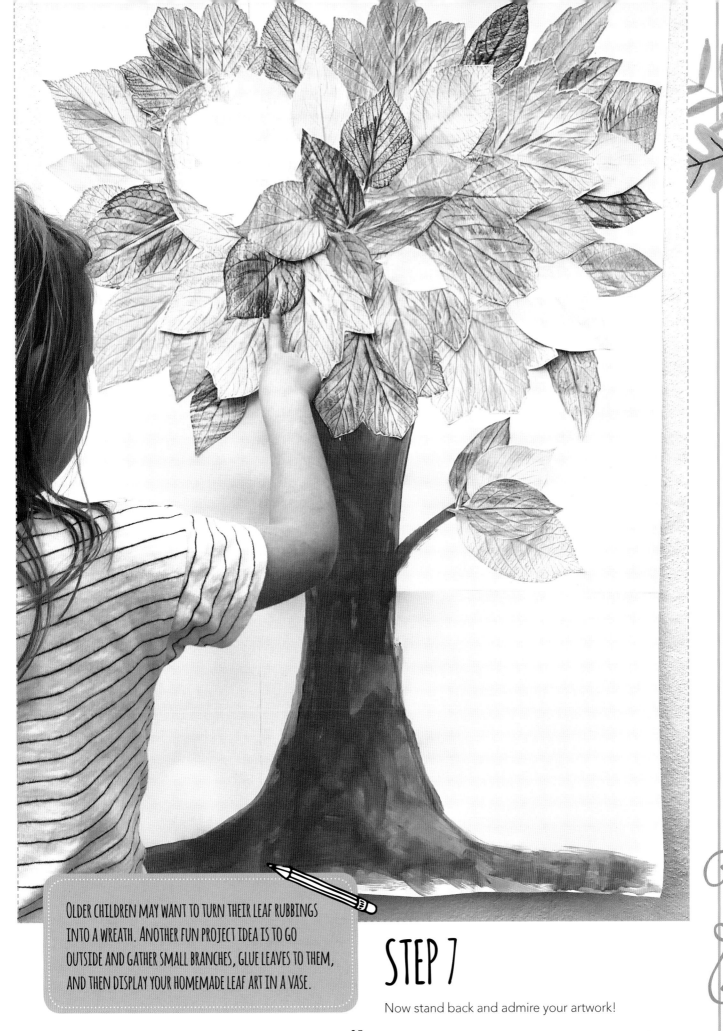

OLDER CHILDREN MAY WANT TO TURN THEIR LEAF RUBBINGS INTO A WREATH. ANOTHER FUN PROJECT IDEA IS TO GO OUTSIDE AND GATHER SMALL BRANCHES, GLUE LEAVES TO THEM, AND THEN DISPLAY YOUR HOMEMADE LEAF ART IN A VASE.

STEP 7

Now stand back and admire your artwork!

BUILDINGS

By learning to draw standard elements, like windows and doors, you'll be able to create a huge variety of building styles, from flat facades to three-dimensional scenes!

FACADES

Let's begin by studying the facade of a house. The flat front offers a good starting point for learning the shapes that make up buildings. The simplest type of house consists of a squat rectangle topped with a triangle and more rectangles for the windows and door.

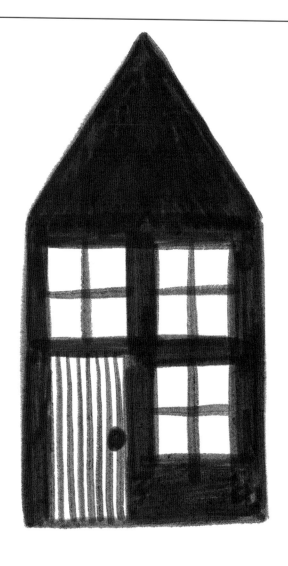

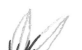

Here are a few more buildings. Notice that each consists of common shapes, which are highlighted in red. Additional details are added afterward.

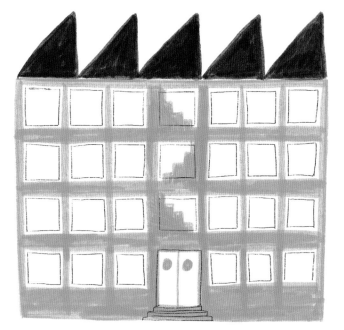
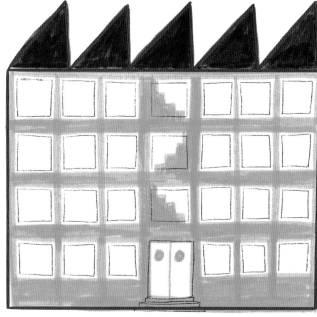
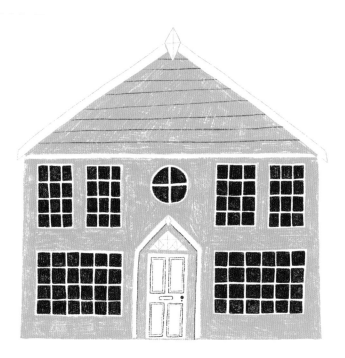
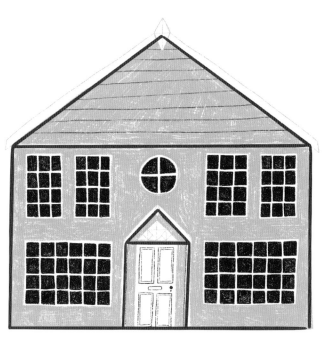

These buildings look a little more complicated, but I drew them using triangles and rectangles!

Here are some examples of doors and windows that you may want to add to your structures.

PRACTICE HERE!

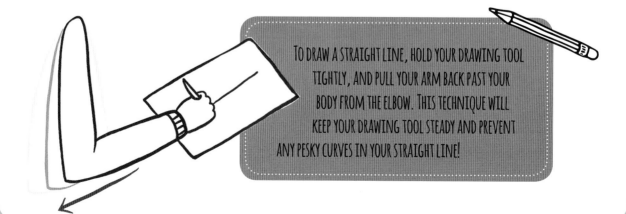

To draw a straight line, hold your drawing tool tightly, and pull your arm back past your body from the elbow. This technique will keep your drawing tool steady and prevent any pesky curves in your straight line!

THREE-DIMENSIONAL BUILDINGS

Drawing a building in 3D takes a little practice, but having some knowledge of perspective, or the illusion of three-dimensionality, will make it much easier. To start, let's learn about vanishing points, or where parallel lines converge in a work of art. Vanishing points help create perspective in a drawing.

ONE-POINT PERSPECTIVE

One-point perspective uses a single vanishing point to show depth in a drawing. You can use one-point perspective to draw a house from the front.

Draw a horizon line and mark a vanishing point on the left side.

Sketch out the front of the house to the right of the vanishing point, with half of the house below the horizon line and half above it. Draw lines connecting the vanishing point to the top- and bottom-left corners of the building. To mark the back of the house, draw a vertical line.

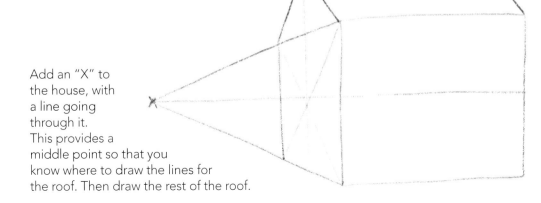

Add an "X" to the house, with a line going through it. This provides a middle point so that you know where to draw the lines for the roof. Then draw the rest of the roof.

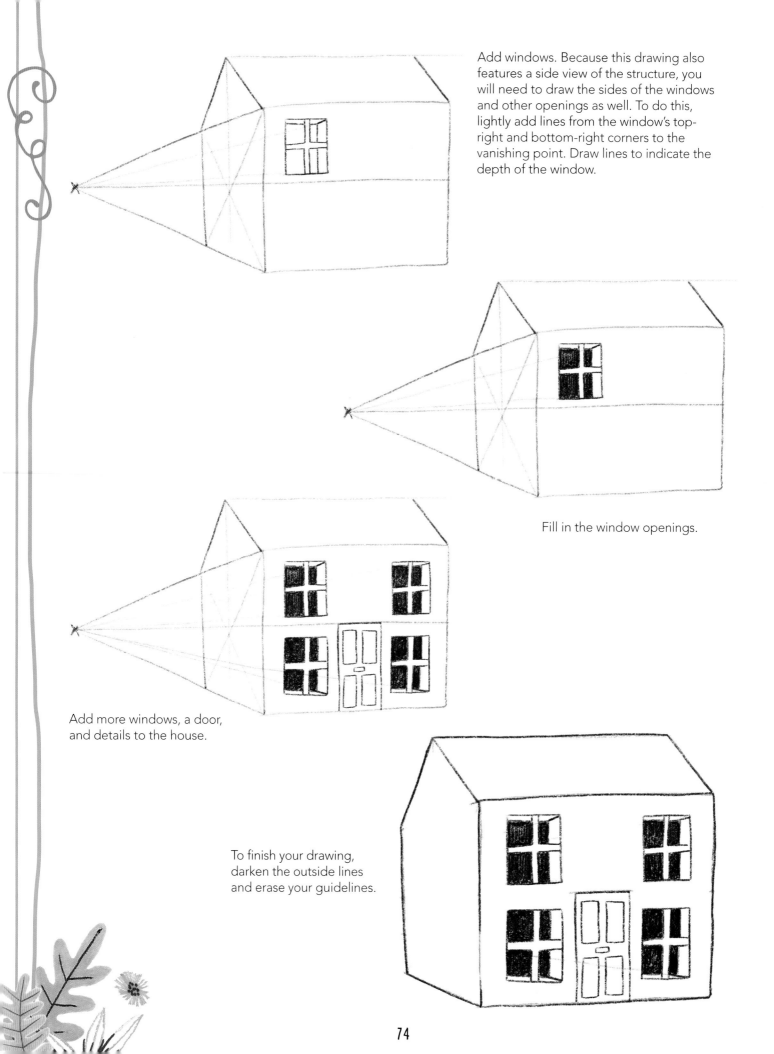

Add windows. Because this drawing also features a side view of the structure, you will need to draw the sides of the windows and other openings as well. To do this, lightly add lines from the window's top-right and bottom-right corners to the vanishing point. Draw lines to indicate the depth of the window.

Fill in the window openings.

Add more windows, a door, and details to the house.

To finish your drawing, darken the outside lines and erase your guidelines.

TWO-POINT PERSPECTIVE

Two-point perspective is similar to one-point perspective, except that there are two vanishing points along the horizon line. You can use two-point perspective to draw a house from a three-quarters angle.

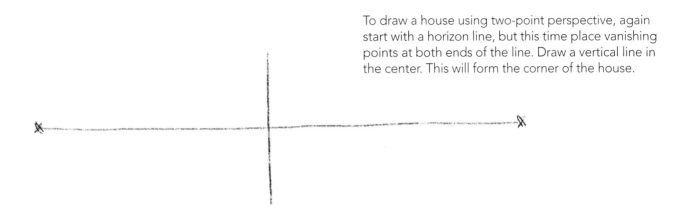

To draw a house using two-point perspective, again start with a horizon line, but this time place vanishing points at both ends of the line. Draw a vertical line in the center. This will form the corner of the house.

Create the side of the house by drawing diagonal guidelines to the vanishing points, and then add vertical lines. Make the line on the left slightly longer than the right one.

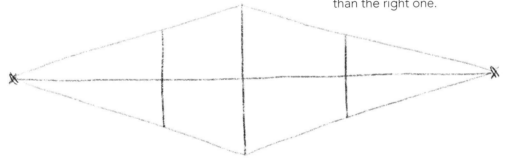

Draw an "X" with a line through it, and then a pitched roof on top of the house.

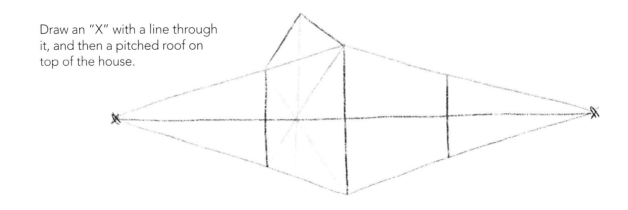

Complete the roof of the house by drawing a line from the top of the pitched roof to the vanishing point on the right, as well as a line to indicate the angle of the roof.

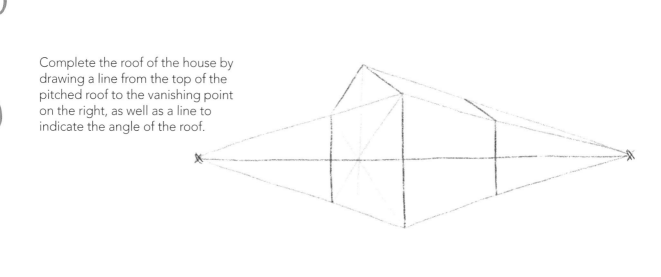

Add windows to the house using lines that meet at the vanishing point on the right, plus vertical lines through the windows.

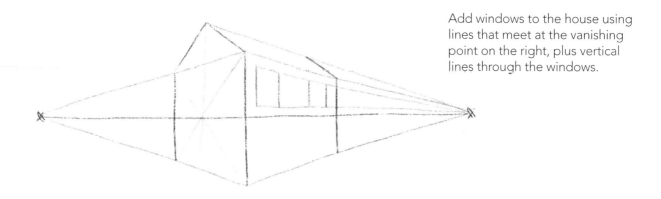

Draw guidelines from the right sides of the windows to the vanishing point on the left. Use these lines to form the interior frames of the windows and to add depth. Also add guidelines from the inside corners of the windows to the right vanishing point.

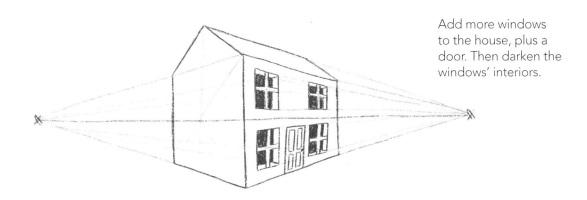

Add more windows to the house, plus a door. Then darken the windows' interiors.

Erase your guidelines and color in the house!

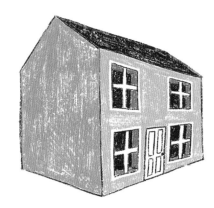

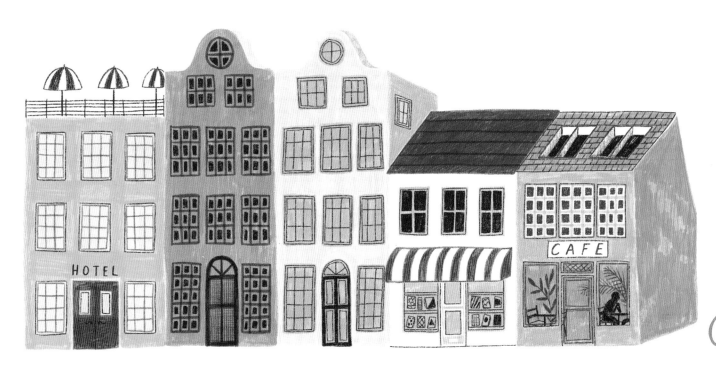

By following one- and two-point perspectives, you can draw houses from any angle. Draw multiple houses to create a street!

MAP

My children love creating maps of their favorite familiar places. It gives us lots to talk about: They tell me about their friends' homes and the places we often go, and then we draw them on the map. My kids also like to drive their miniature cars through their hand-drawn maps! Use your building-drawing skills (see pages 68–77) to help your kids create houses from different angles.

Tools & Materials

- Several sheets of white printer paper
- Tape
- Scissors
- Markers
- Optional: masking tape or washi tape

STEP 1

AS YOU TAPE TOGETHER YOUR SHEETS OF PAPER, ASK YOUR KIDS WHAT THEY'D LIKE TO INCLUDE ON THEIR MAP.

Lay out your sheets of paper, and tape them together to form a single, large piece of paper, without overlapping the edges. We used nine sheets of paper, but you should feel free to use as many as you like. You can always add sheets later to enlarge your map!

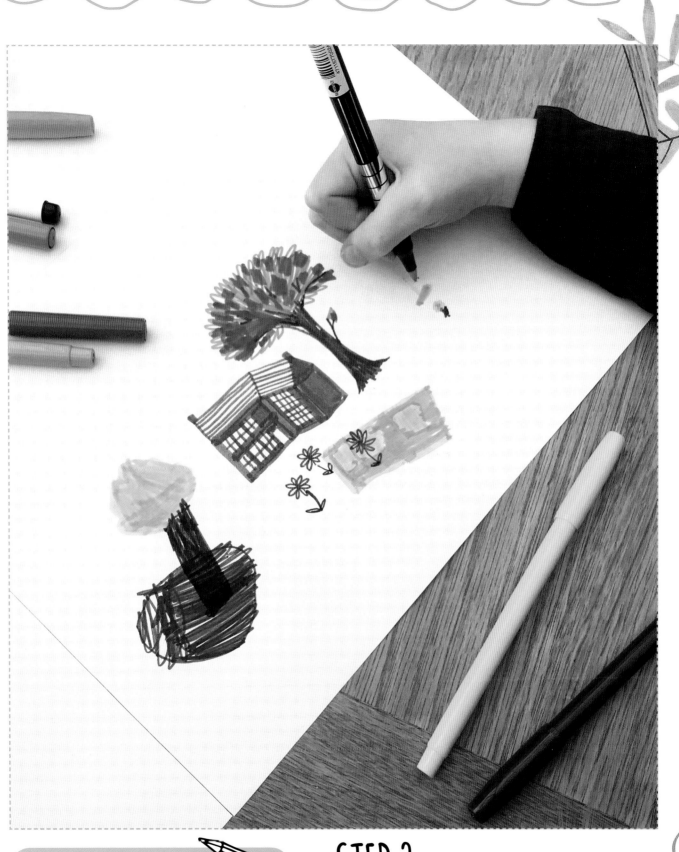

Be as detailed as you like with your drawings, but keep in mind that you will want to keep them small so that there's room for everything you want to add!

STEP 2

Flip over the sheets of paper so that the tape is on the back. Then begin drawing. I usually like to start with our home, and I ask my kids where they envision it to be.

STEP 3

Ask your kids what their favorite places are, and draw a road from your home to the next location on your map. Make sure the road is wide enough for a toy car!

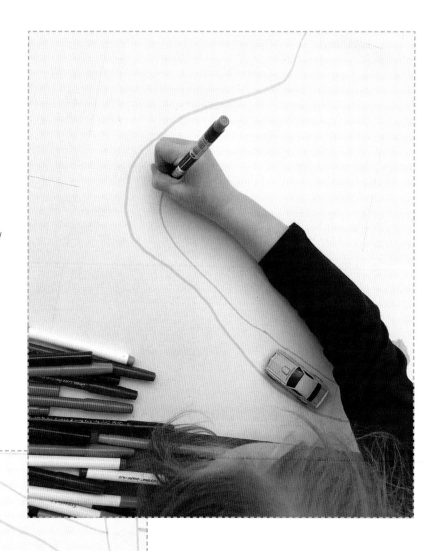

STEP 4

Add the next location to your map. We drew the small house we pass on the way to school!

THE STREETS ON YOUR MAP DON'T HAVE TO BE STRAIGHT; THINK ABOUT THE FAMILIAR BENDS AND TWISTS IN THE ROADS YOU DRIVE ON REGULARLY.

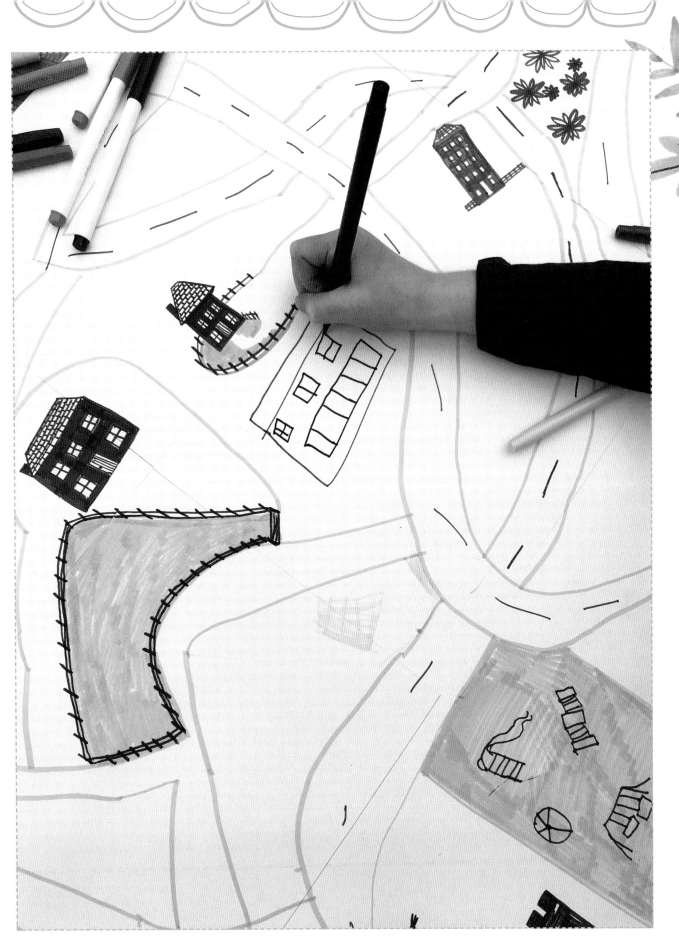

STEP 5

Continue adding locations to the map. You can draw roads, intersections, the park, the grocery store, and so on. Get your kids even more involved and have them draw buildings and places, in addition to decorating your drawings!

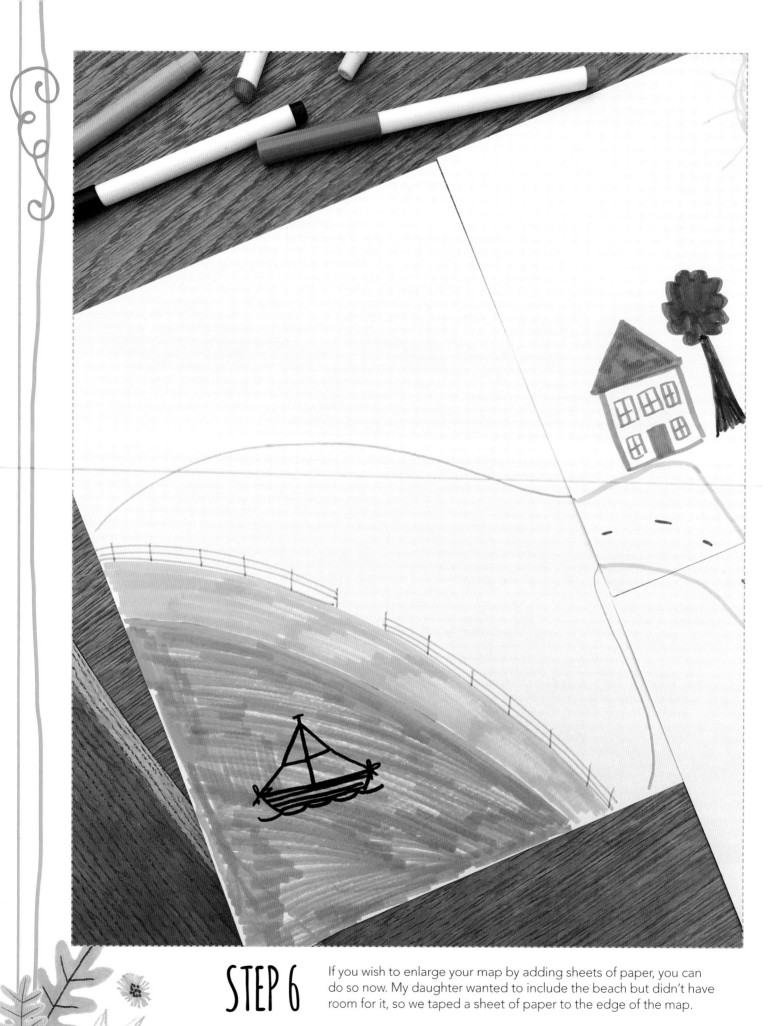

STEP 6

If you wish to enlarge your map by adding sheets of paper, you can do so now. My daughter wanted to include the beach but didn't have room for it, so we taped a sheet of paper to the edge of the map.

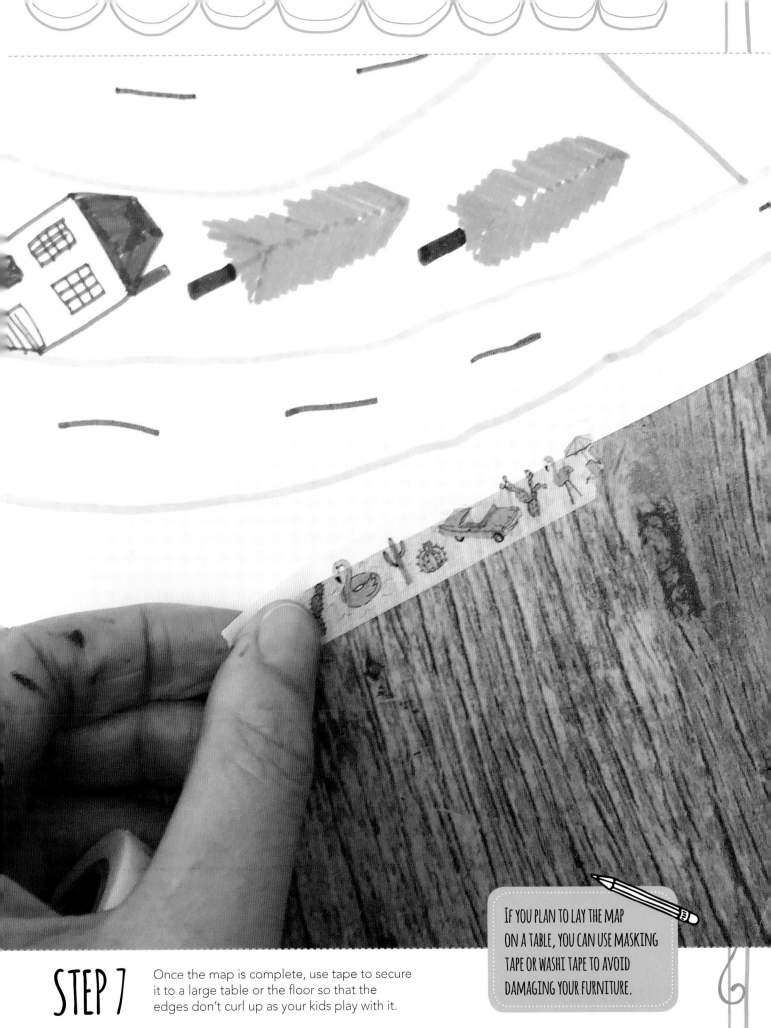

STEP 7

Once the map is complete, use tape to secure it to a large table or the floor so that the edges don't curl up as your kids play with it.

IF YOU PLAN TO LAY THE MAP ON A TABLE, YOU CAN USE MASKING TAPE OR WASHI TAPE TO AVOID DAMAGING YOUR FURNITURE.

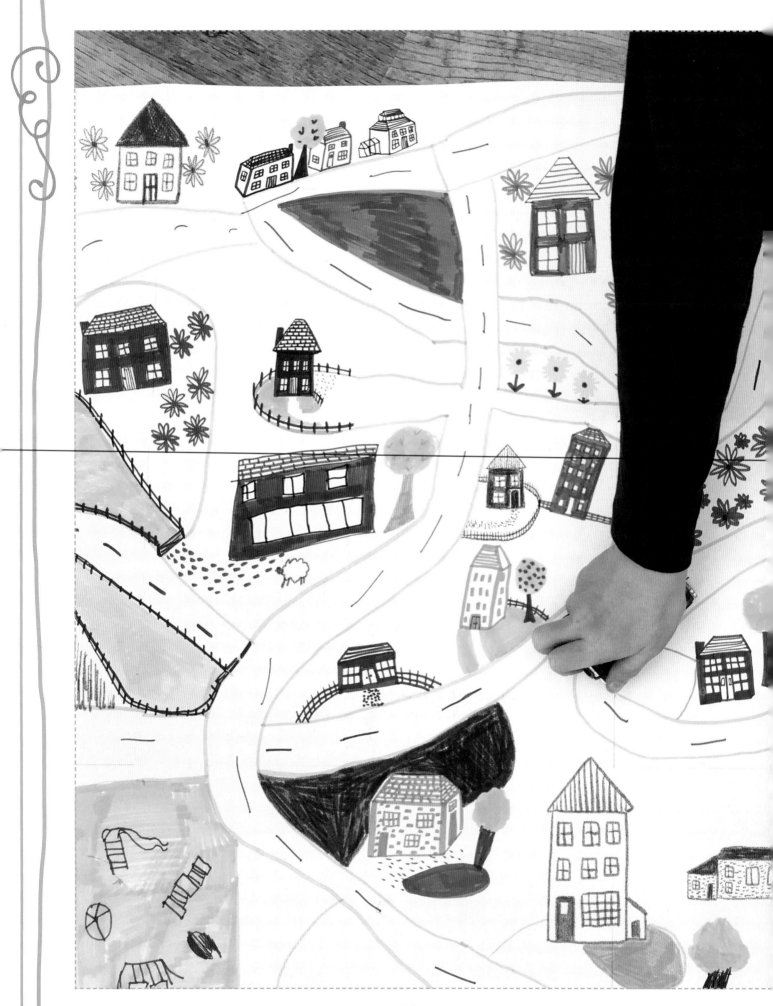

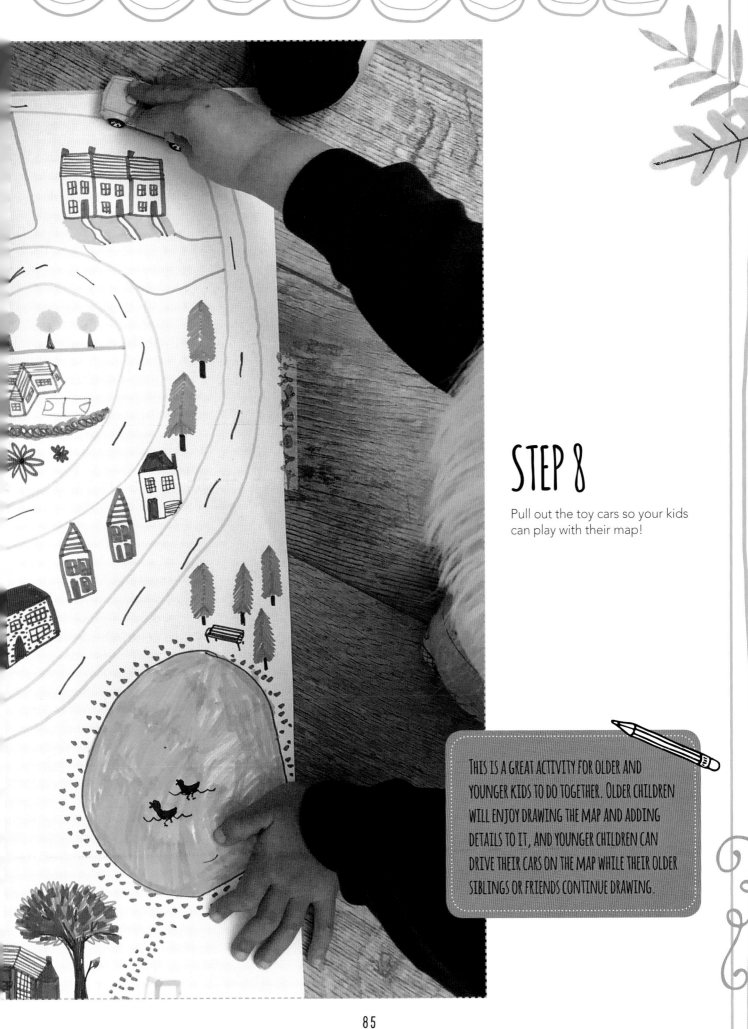

STEP 8

Pull out the toy cars so your kids can play with their map!

THIS IS A GREAT ACTIVITY FOR OLDER AND YOUNGER KIDS TO DO TOGETHER. OLDER CHILDREN WILL ENJOY DRAWING THE MAP AND ADDING DETAILS TO IT, AND YOUNGER CHILDREN CAN DRIVE THEIR CARS ON THE MAP WHILE THEIR OLDER SIBLINGS OR FRIENDS CONTINUE DRAWING.

REPTILES, SEA ANIMALS, DINOSAURS, AND MORE

REPTILES & AMPHIBIANS

Your children will love seeing your illustrated reptiles, sea animals, and dinosaurs! Their scales and patterns make great practice material for a beginning artist, and finished drawings can be incorporated into a variety of fun craft projects, including the shadow puppet theater that follows this tutorial (pages 98–103).

As you discovered when you learned to draw animals (see pages 12–19), the best way to draw a reptile or an amphibian is to start with its form. Make a rough sketch of the animal's basic shapes, and then build on that sketch to add legs and a tail before coloring and drawing the details.

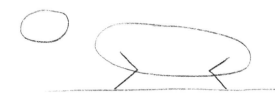

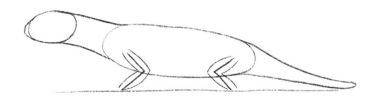

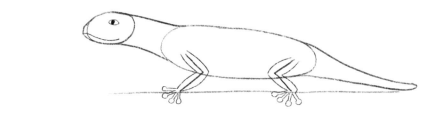

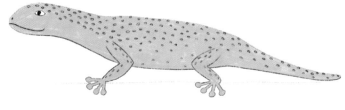

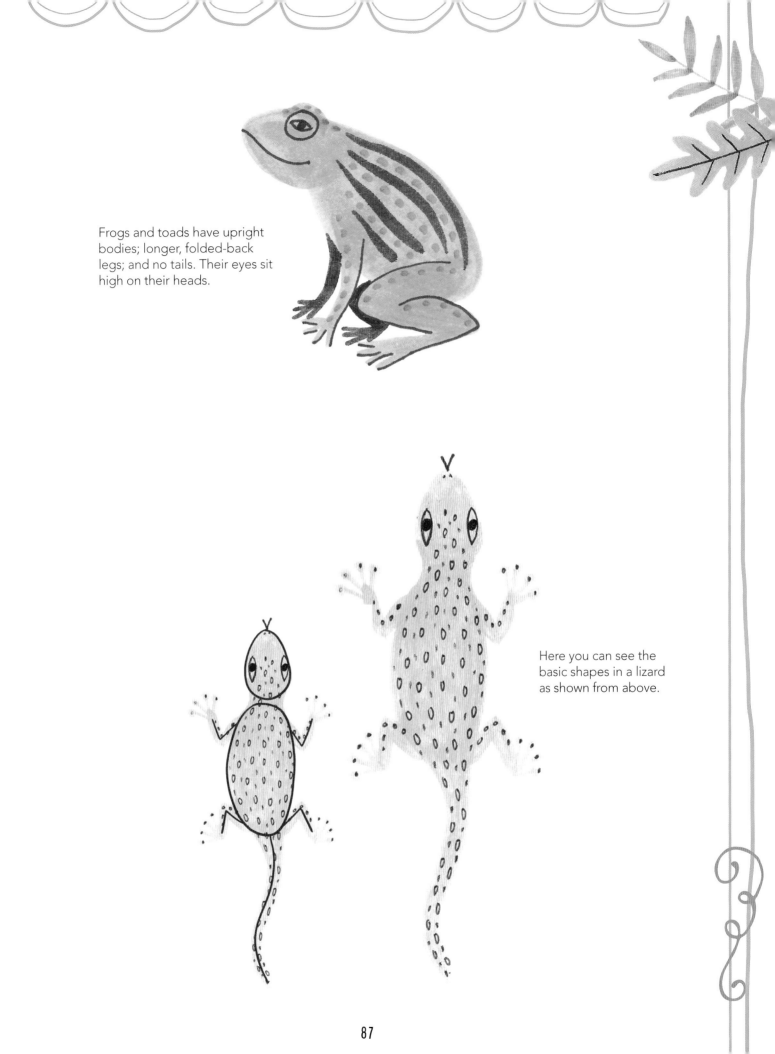

Frogs and toads have upright bodies; longer, folded-back legs; and no tails. Their eyes sit high on their heads.

Here you can see the basic shapes in a lizard as shown from above.

A chameleon looks similar to a lizard, but it has a lower head. Its back curves upward and then follows the same line into the tail.

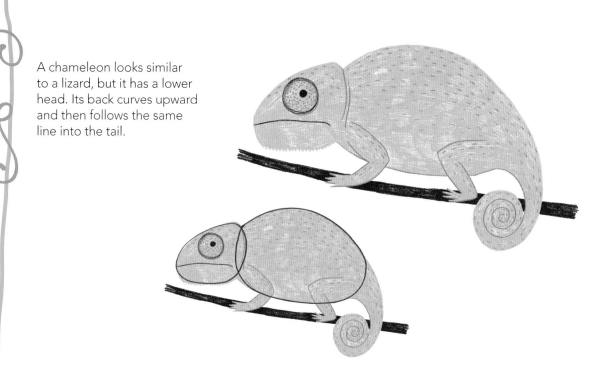

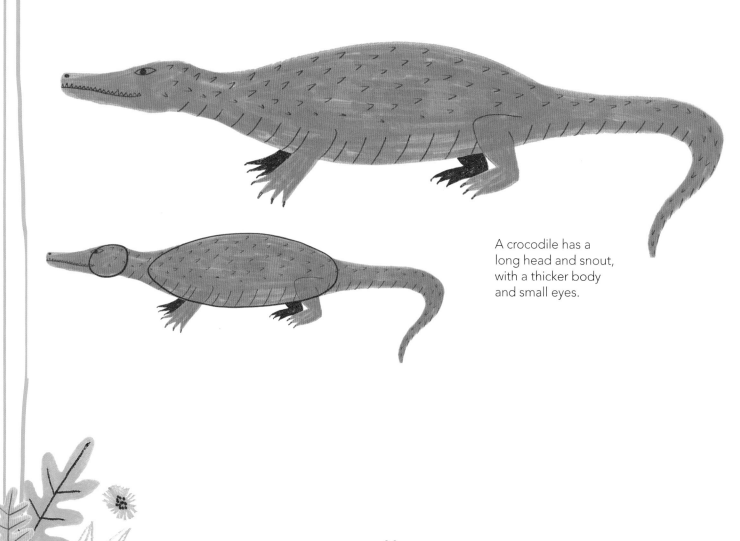

A crocodile has a long head and snout, with a thicker body and small eyes.

Snakes are easy to draw; however, it is still helpful to start with an outline of the body. A snake consists of ovals, big and small curves, and a narrow tail. Try drawing a snake from the side and then from above.

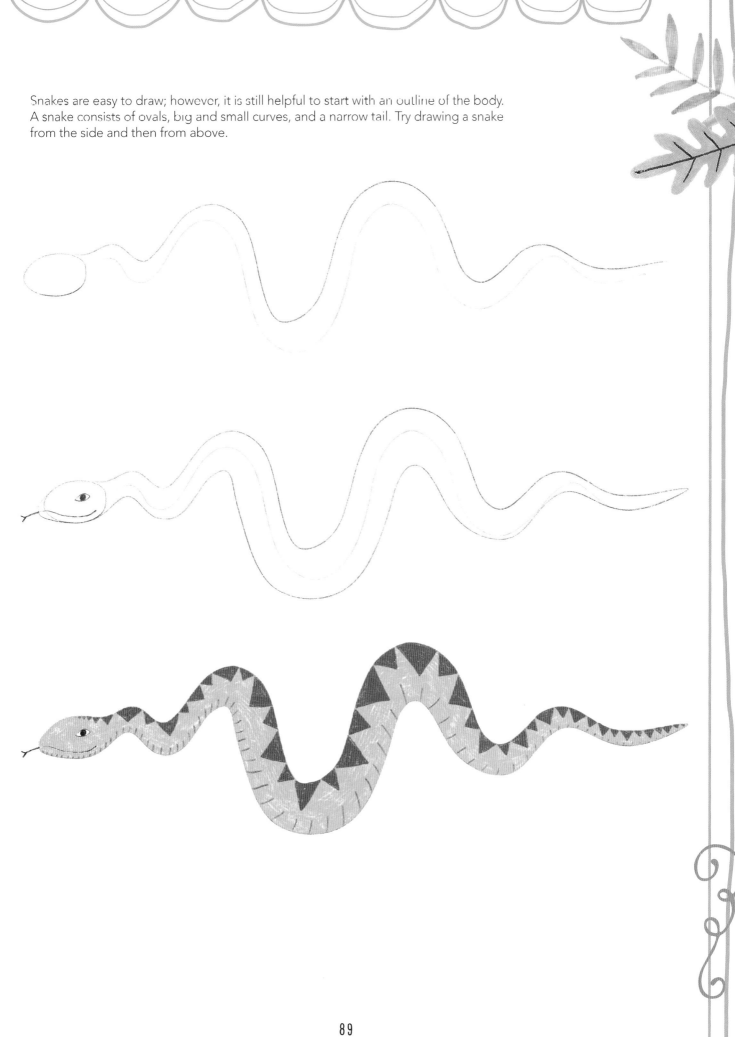

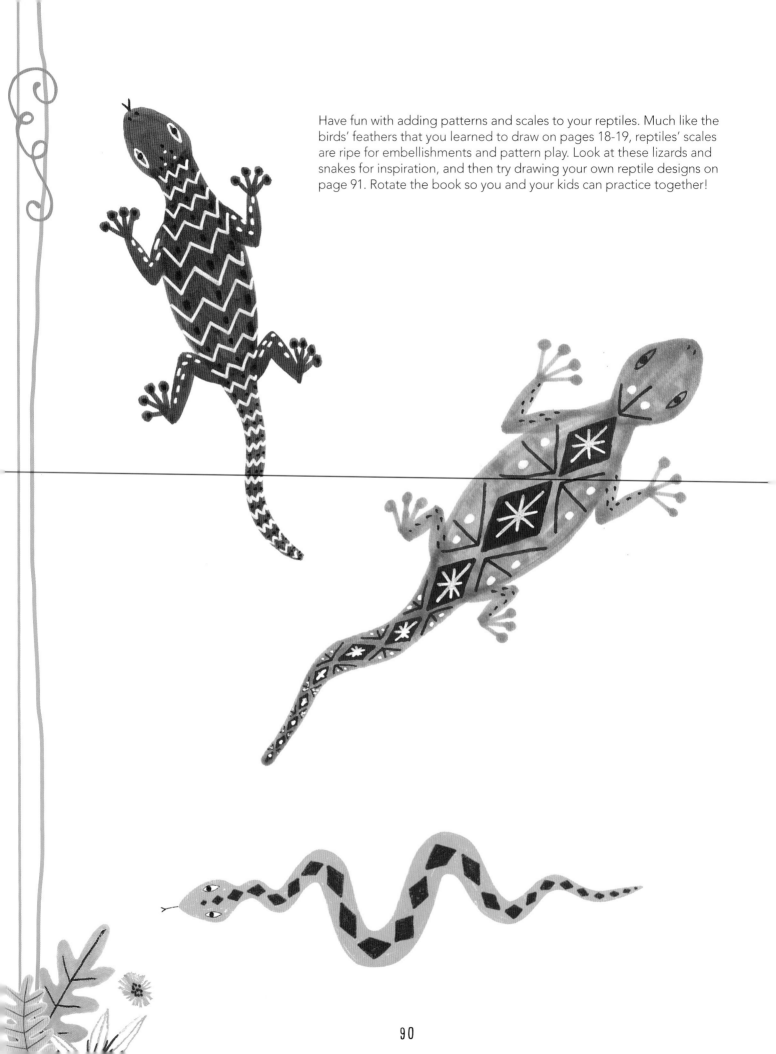

Have fun with adding patterns and scales to your reptiles. Much like the birds' feathers that you learned to draw on pages 18-19, reptiles' scales are ripe for embellishments and pattern play. Look at these lizards and snakes for inspiration, and then try drawing your own reptile designs on page 91. Rotate the book so you and your kids can practice together!

DINOSAURS

Dinosaurs can be drawn like any other animal. Start by looking at reference images online to determine a dinosaur's typical body shape and where the head and body sit in relation to one another. Also, take notice of the thickness and length of the dinosaur's legs and neck.

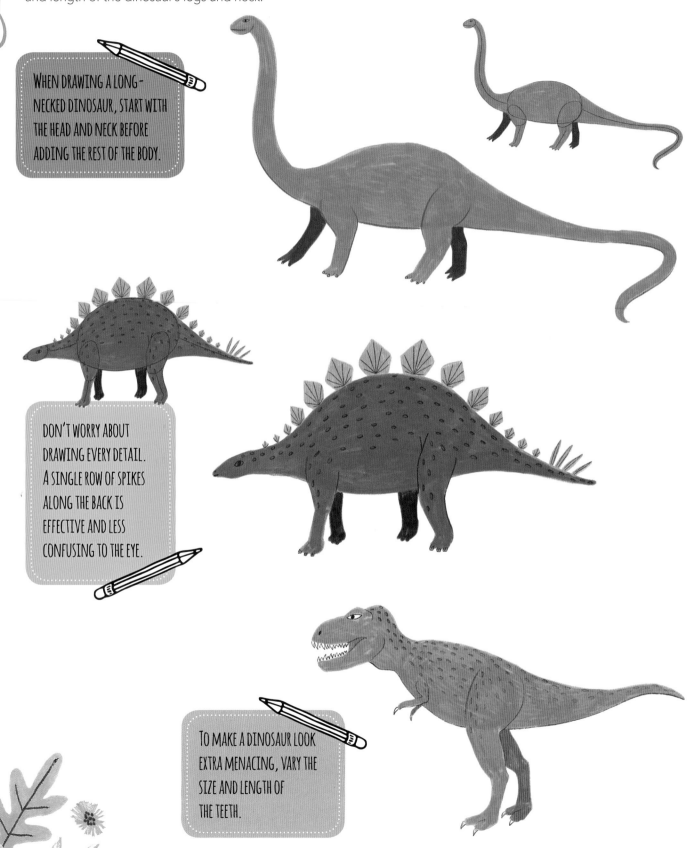

WHEN DRAWING A LONG-NECKED DINOSAUR, START WITH THE HEAD AND NECK BEFORE ADDING THE REST OF THE BODY.

DON'T WORRY ABOUT DRAWING EVERY DETAIL. A SINGLE ROW OF SPIKES ALONG THE BACK IS EFFECTIVE AND LESS CONFUSING TO THE EYE.

TO MAKE A DINOSAUR LOOK EXTRA MENACING, VARY THE SIZE AND LENGTH OF THE TEETH.

SEA ANIMALS

Underwater scenes are lots of fun to draw, whether you want to create fish, whales, shellfish, or something else. Here are a few creatures to help you get started.

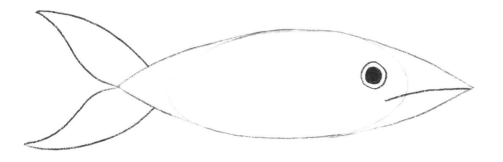

Fish come in many shapes and sizes. Make your fish as simple or as detailed as you'd like. Once you've drawn a basic fish, try different shapes and spiky or feathered fins.

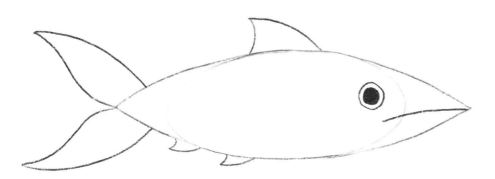

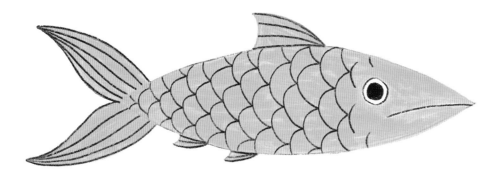

To draw scales, start with a scalloped line, and then add rows beneath it, ensuring that the pointed part of each scallop hits the center of the scallop above.

1.
2.
3.

For additional inspiration, here are a few more fish and scale patterns to try.

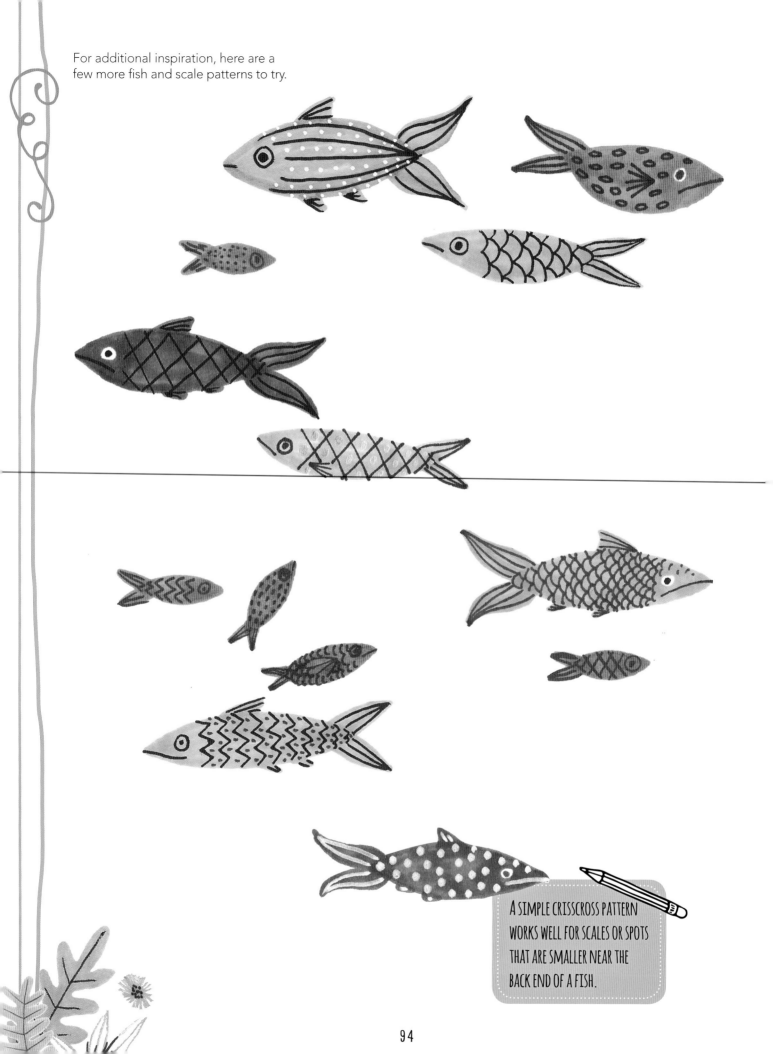

A SIMPLE CRISSCROSS PATTERN WORKS WELL FOR SCALES OR SPOTS THAT ARE SMALLER NEAR THE BACK END OF A FISH.

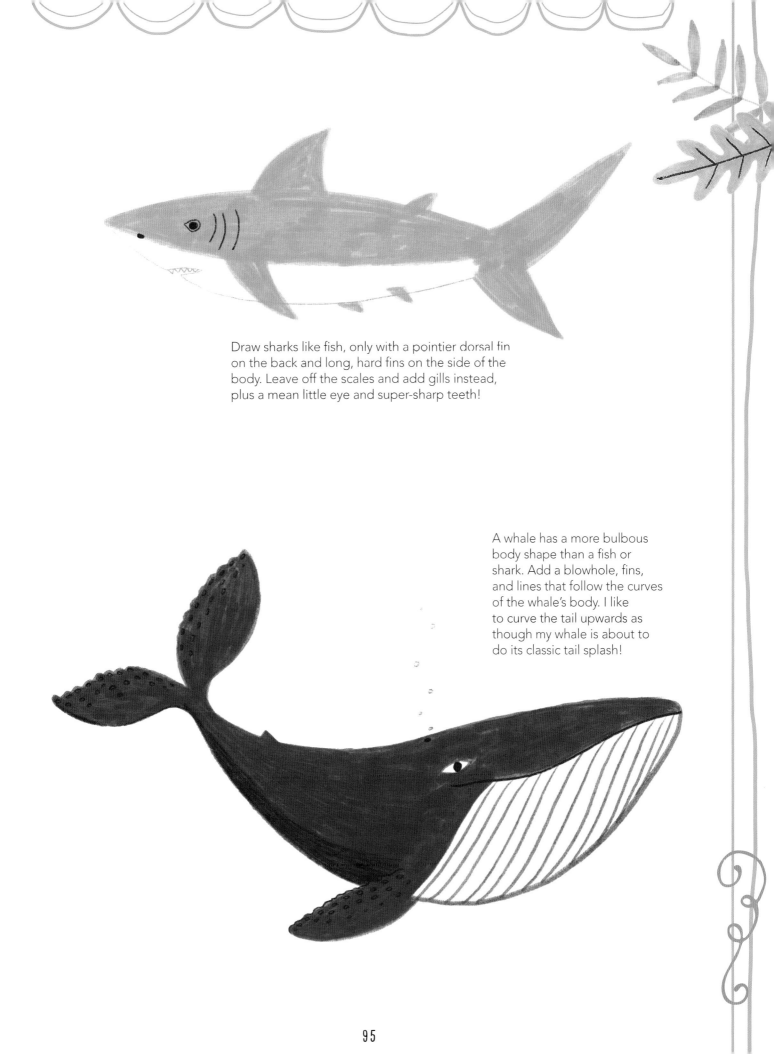

Draw sharks like fish, only with a pointier dorsal fin on the back and long, hard fins on the side of the body. Leave off the scales and add gills instead, plus a mean little eye and super-sharp teeth!

A whale has a more bulbous body shape than a fish or shark. Add a blowhole, fins, and lines that follow the curves of the whale's body. I like to curve the tail upwards as though my whale is about to do its classic tail splash!

Crabs can be drawn in segments that are then colored in, making them fairly simple and a lot of fun to draw! Create light guidelines for the legs, and add rounded rectangles on top, before drawing the claws.

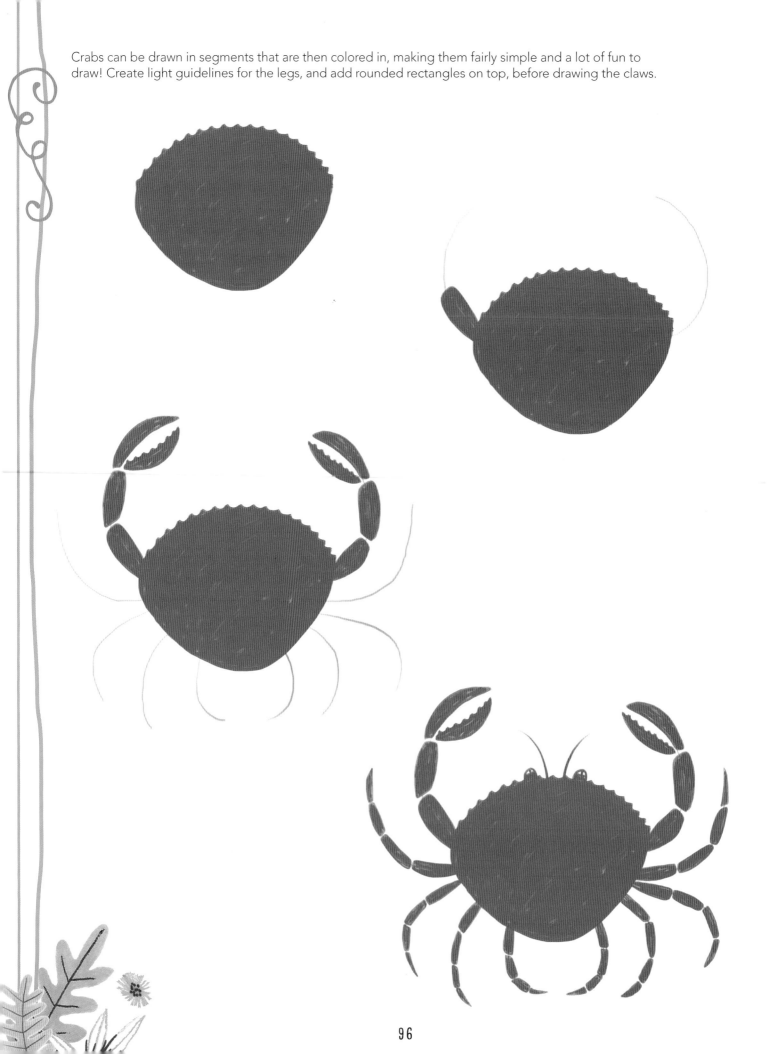

Shells and starfish make lovely additions to decorative pieces and can be embellished with interesting patterns.

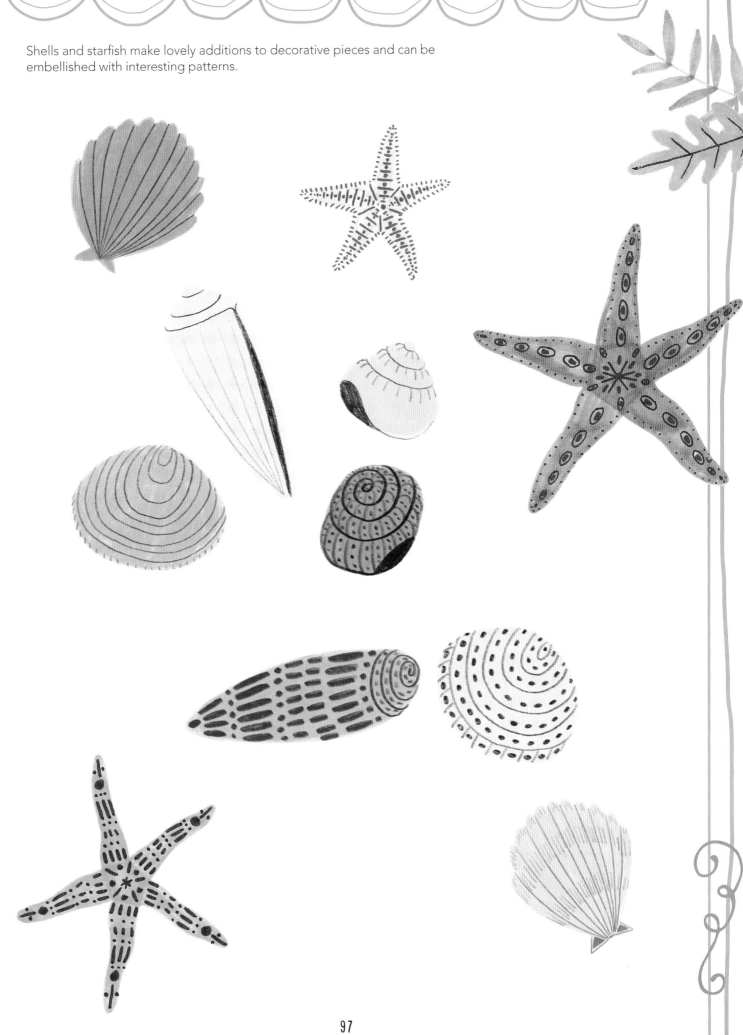

Shadow Puppet Theater

Making shadow puppets with your kids is a fun way to spend an afternoon. Kids will not only love making the puppets, they can also come up with characters and a story, devise a play, and put on a performance for you!

Tools & Materials

- Large cereal box
- Craft knife and cutting mat (for grown-ups' use only!) OR scissors
- Clear tape
- Several sheets of tracing paper
- Black and colorful markers
- Masking tape or washi tape
- Lollipop sticks or wooden skewers, with the sharp tips removed

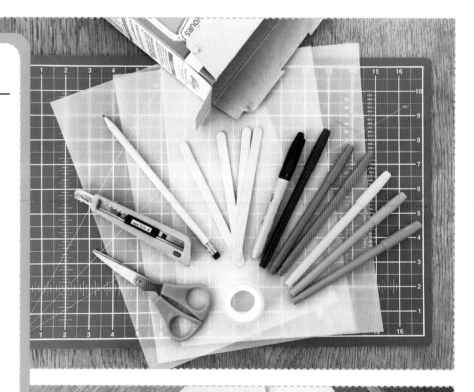

STEP 1

Cut off one of the large sides of the cereal box. Using the other side of the box, cut out a rectangle, leaving a 1-inch edge on all sides so that it looks like a television screen. Keep the extra cardboard to use for your puppets.

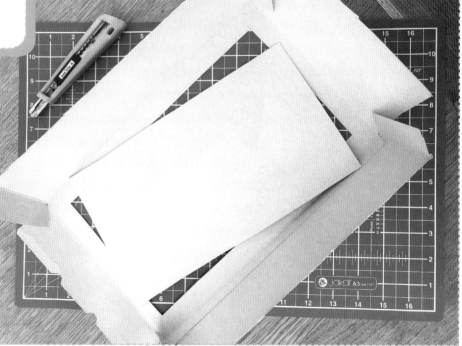

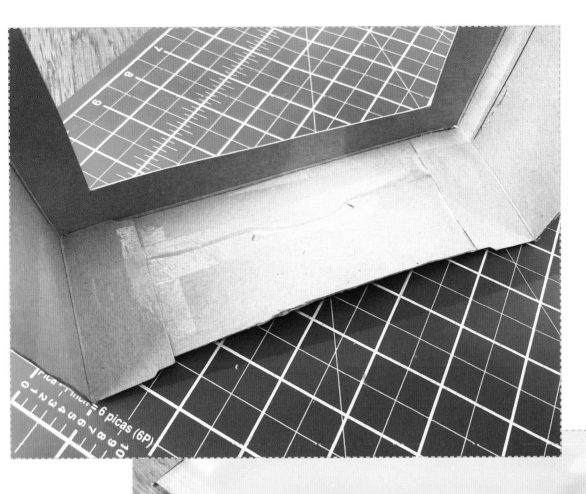

STEP 2

Use tape to reattach the ends of the box.

YOU MAY NEED TO USE TWO SHEETS OF TRACING PAPER TO COVER THE HOLE ENTIRELY. IF YOU USE TWO SHEETS OF TRACING PAPER, DON'T OVERLAP THEIR EDGES, AND ATTACH THEM USING CLEAR TAPE.

STEP 3

Place tracing paper over the screen.

STEP 4

Ask your kids which animals they'd like to include in their puppet show. Choose three or four, and sketch them onto the extra cardboard you saved in step 1. Make each animal about 4 to 6 inches in size.

Add details to the animals and darken their outlines. Ask your child where he or she thinks the eyes and other markings should go, and slightly exaggerate these features. You will need to cut out these animals, so don't make them too complicated!

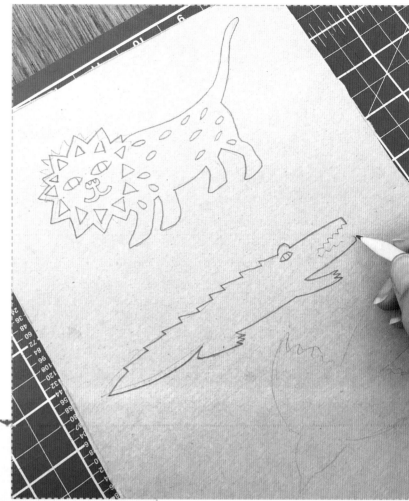

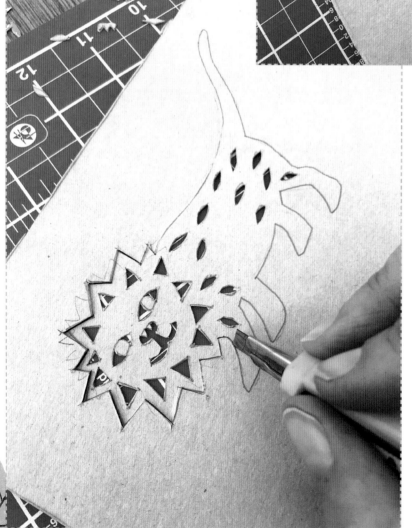

WITH THE POINTY END OF YOUR SCISSORS, PUNCTURE A SPOT ON THE OUTLINE OF YOUR ANIMAL TO ASSIST WITH CUTTING THROUGH THE CARDBOARD.

STEP 5

Cut out the animals using a craft knife and a cutting mat or a sharp pair of scissors.

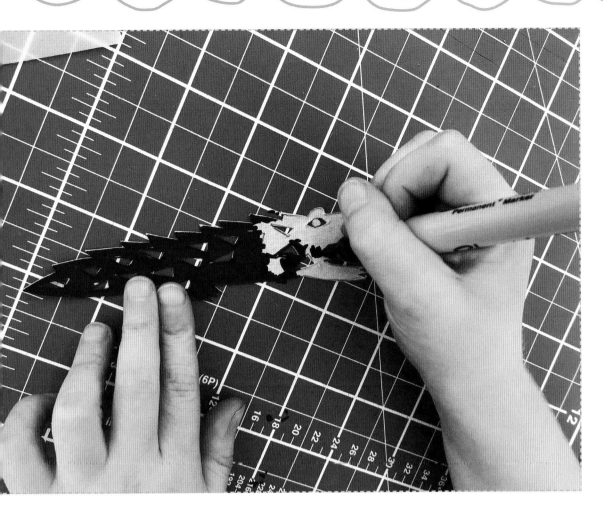

STEP 6

Ask your child to color in the animals using a black marker.

STEP 7

On a sheet of tracing paper, have your child make some flat areas of color using markers.

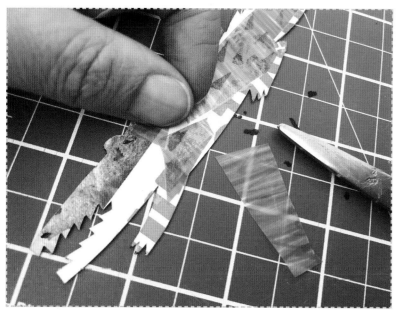

STEP 8

Cut out the colorful scraps of paper. Turn over the puppets, and then use your flat areas of color to cover the holes in the puppets like a stained-glass window.

Use tape to attach the colored paper to the cardboard puppets. Cut off the overhang, or fold it back.

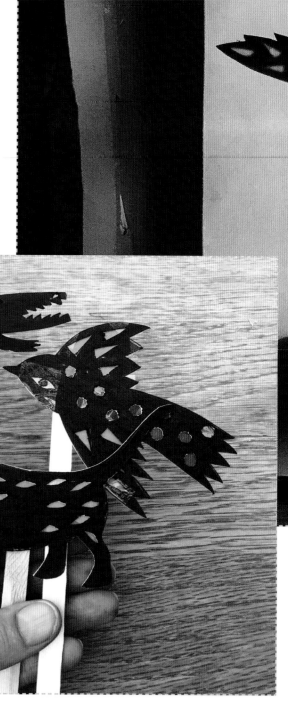

USE MASKING TAPE OR WASHI TAPE TO SECURE THE SHADOW BOX TO THE EDGE OF THE TABLE WHERE YOUR KIDS WILL DO THE PERFORMANCE.

STEP 9

Attach your lollipop sticks or skewers to the backs of the puppets using tape.

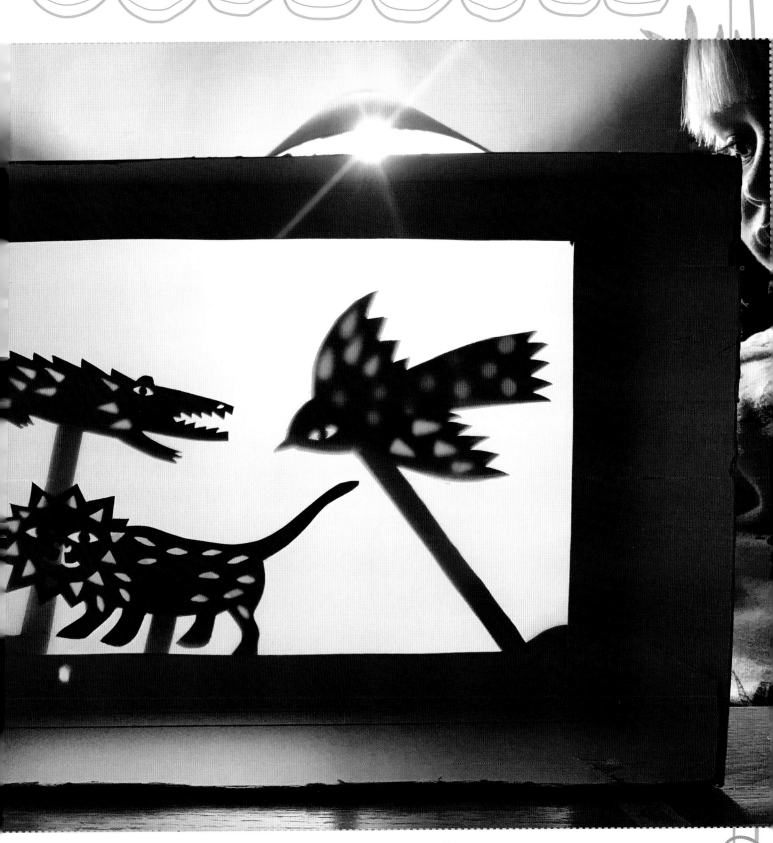

STEP 10

You will need a light source behind the shadow box. If it's daytime, place the shadow box in front of a window. If it's dark outside, use a lamp and dim the lighting in the room.

With the puppeteer ducking down behind the table, so that just the puppets are visible, let the show begin!

ROBOTS

Robots feature heavily in children's books, and you will likely be asked to draw them at some point. Draw them as simple, boxy figures, or go more futuristic and create humanoid robots! Let's start by drawing a simplistic robot using pencil.

Draw a square body and head, with a short neck in between.

Add facial features, lights, and screens to the robot's head and body.

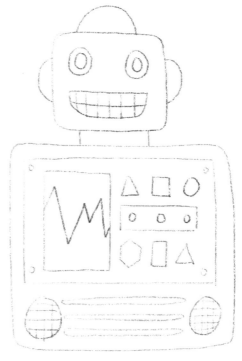

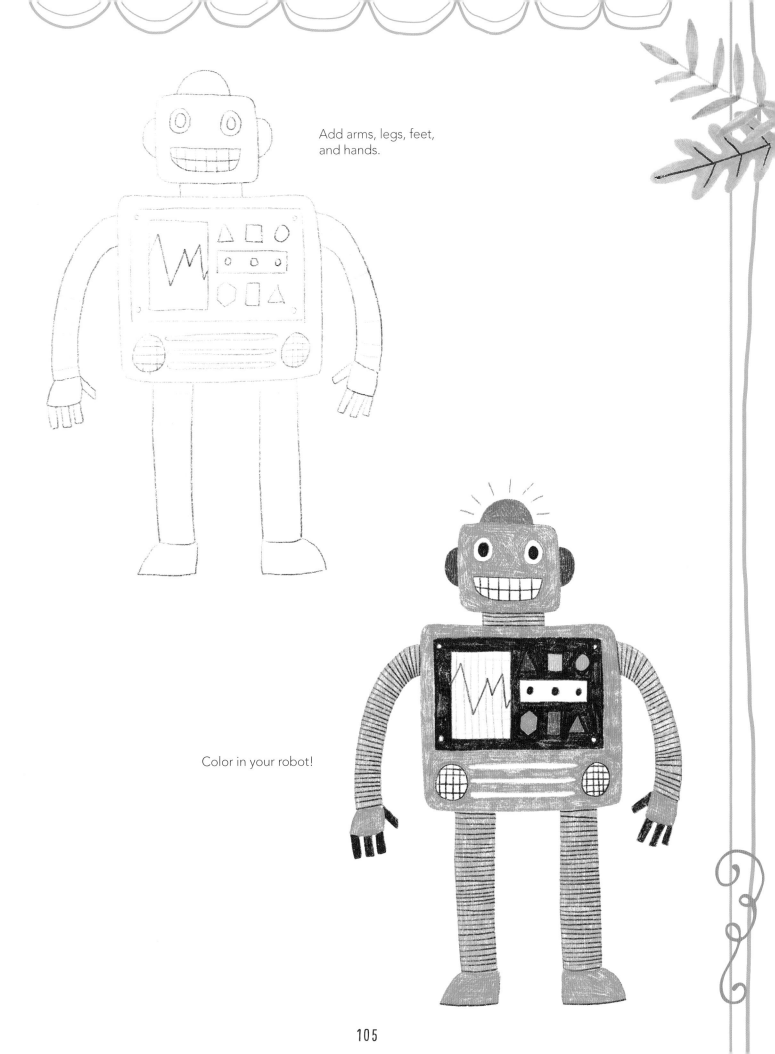

Add arms, legs, feet, and hands.

Color in your robot!

105

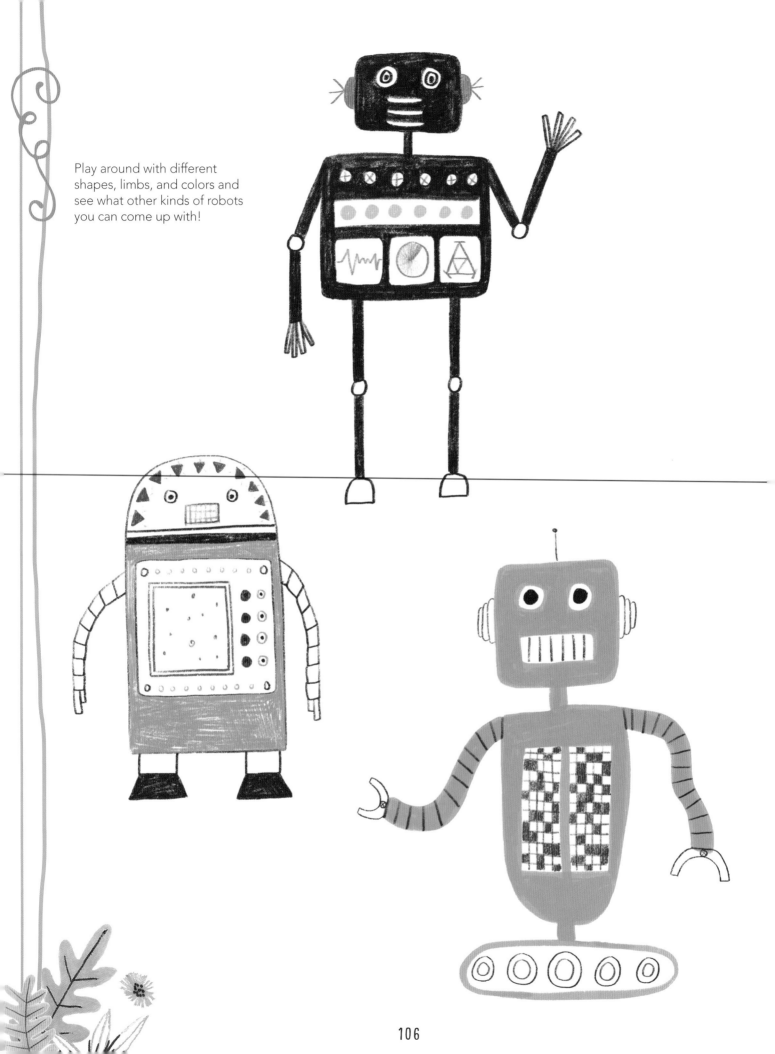

Play around with different shapes, limbs, and colors and see what other kinds of robots you can come up with!

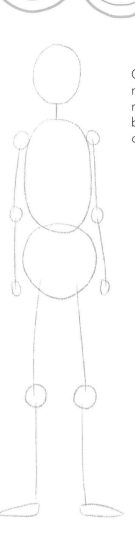

Older children might like to see a more futuristic, humanoid type of robot. To draw one, start with the basic shapes in a human body, as described on page 47.

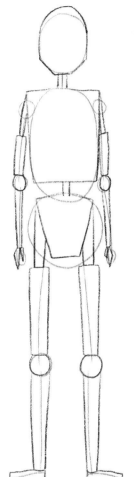

Add body parts over the robot's basic shapes. Use hard corners; the robot shouldn't look *too* human!

Add more elements to your robot, such as arm and leg shields, a helmet, and lights.

Finish by adding color.

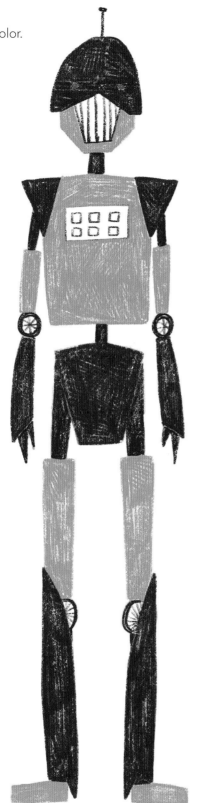

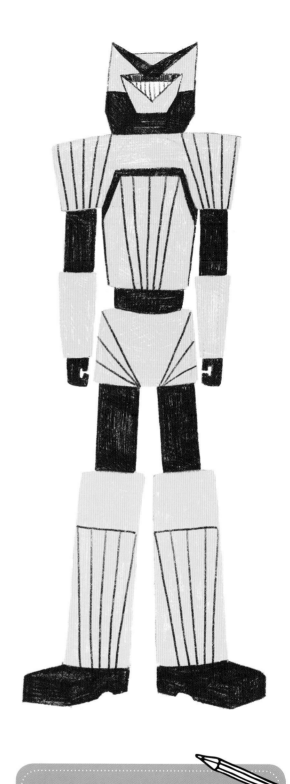

Now that you've learned how to draw two types of robots, feel free to make up your own! The robots you draw are limited only by your imagination. Try adding cogs, buttons, wheels, antennae...maybe even a robot pet!

PRACTICE HERE!

CONSEQUENCES DRAWING GAME

This next project is more of a game than an art project, but it makes for a fun, kid-friendly activity on a rainy day. Plus, if you spend some time on the drawings, you'll end up with some really silly keepsake art to hang in your home!

You'll need at least two people to play this game. It's inspired by the traditional game of Consequences, in which players take turns adding words to a sheet of paper in order to write a story. This time, however, you and your kids will draw funny-looking robots!

TOOLS & MATERIALS

- Printer paper
- Plenty of drawing tools (We used markers, but crayons or colored pencils work just as well...anything goes!)

STEP 1

Use a sheet of paper for each person playing the game. Fold the paper into three equal sections. The robot's head will go in the top section, the middle will feature the body, and at the bottom will go the legs and/or wheels.

STEP 2

Have each player draw a robot's head and neck in the top section of the paper. The head can be as small or large as each player likes; just make sure it's centered

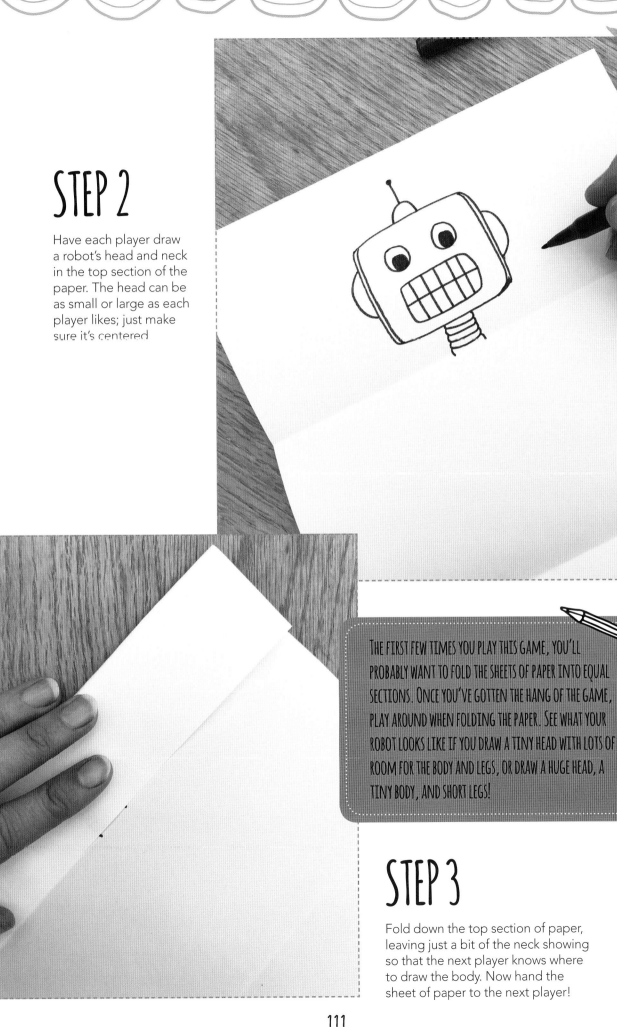

THE FIRST FEW TIMES YOU PLAY THIS GAME, YOU'LL PROBABLY WANT TO FOLD THE SHEETS OF PAPER INTO EQUAL SECTIONS. ONCE YOU'VE GOTTEN THE HANG OF THE GAME, PLAY AROUND WHEN FOLDING THE PAPER. SEE WHAT YOUR ROBOT LOOKS LIKE IF YOU DRAW A TINY HEAD WITH LOTS OF ROOM FOR THE BODY AND LEGS, OR DRAW A HUGE HEAD, A TINY BODY, AND SHORT LEGS!

STEP 3

Fold down the top section of paper, leaving just a bit of the neck showing so that the next player knows where to draw the body. Now hand the sheet of paper to the next player!

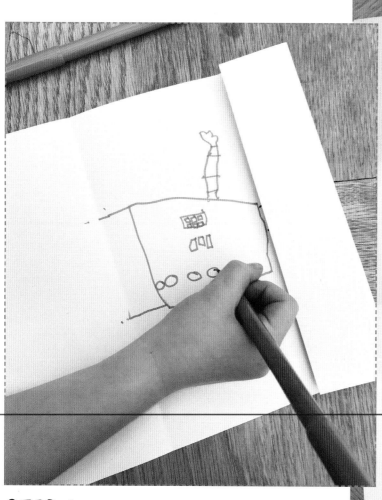

STEP 4

In the middle section of the paper, each player will draw the robot's body. Then fold down the paper, allowing the bottom sliver of the body to show so that the next player knows where to draw the rest of the robot. Again, hand the paper to the next player!

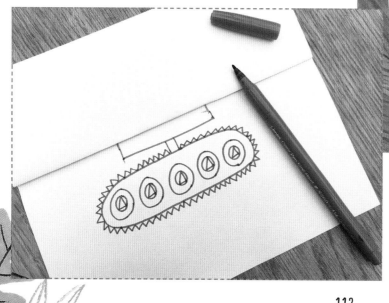

STEP 5

Draw the robot's legs or wheels in the bottom section of the sheet of paper.

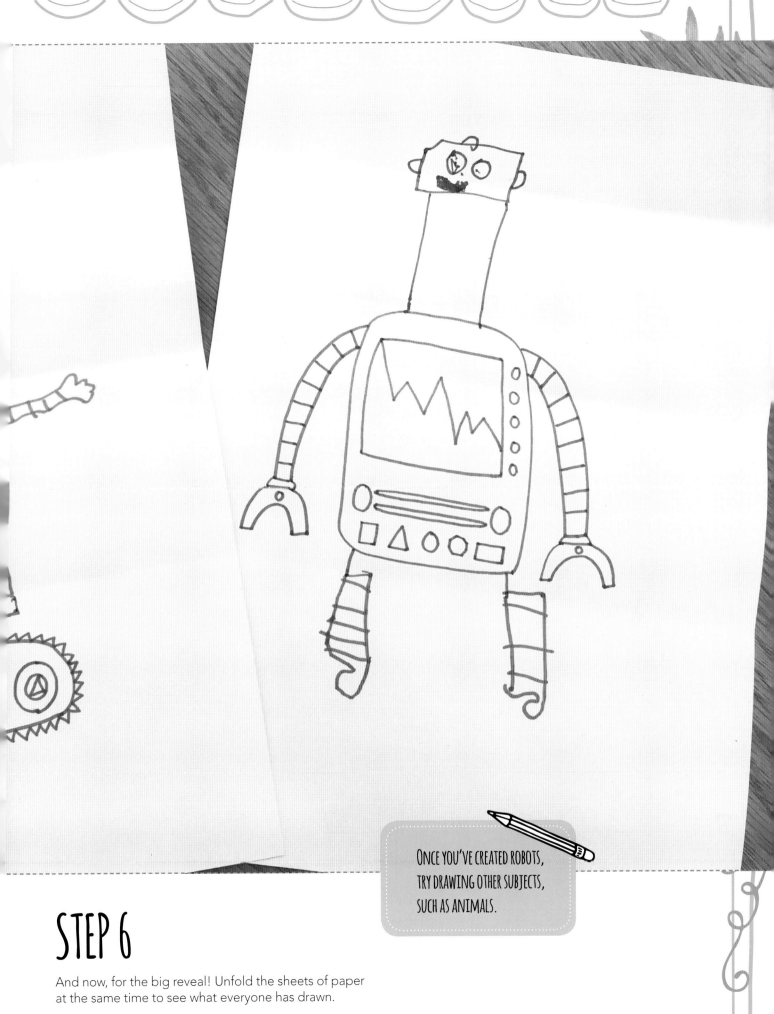

ONCE YOU'VE CREATED ROBOTS,
TRY DRAWING OTHER SUBJECTS,
SUCH AS ANIMALS.

STEP 6

And now, for the big reveal! Unfold the sheets of paper
at the same time to see what everyone has drawn.

FOOD & BEVERAGES

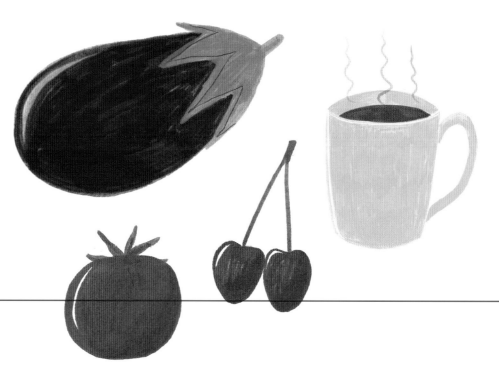

It may not seem like an obvious item to draw, but food was one of the subjects my kids most often asked to see when they were very young. Describing and then drawing the fruits and vegetables helped my children learn to speak, and we still have a lot of fun concocting fantastic feasts using just markers and pencils!

FRUITS & VEGETABLES

Accurately capturing fruits and vegetables requires getting their shapes and colors right. From there, just add simple details.

Start with the outline of the object you're drawing—in this case, an apple.

Color in the apple, leaving a highlight on one side. Then add another layer of color, pressing harder with your drawing tool and adding more color on the side opposite from the highlight to create a rounded shadow.

Add details, like additional color, a stem, and maybe a leaf.

To draw fruits with texture, add little marks to create seeds and pitted skin. Using a white gel or paint pen for the seeds adds a fun touch to this strawberry.

Pineapples are a lot of fun to draw. Use crisscrossed lines and dots to depict their pattern, or go more complicated and draw a series of fan shapes!

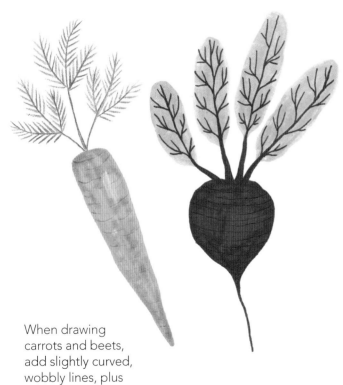

When drawing carrots and beets, add slightly curved, wobbly lines, plus sprouting leaves on top.

For pumpkins and peppers, draw soft, curving lines and finish with a little stalk on top.

Some fruits and vegetables look even more interesting—and recognizable—when cut open. I used simple shapes to draw these items, but it's still clear what they are.

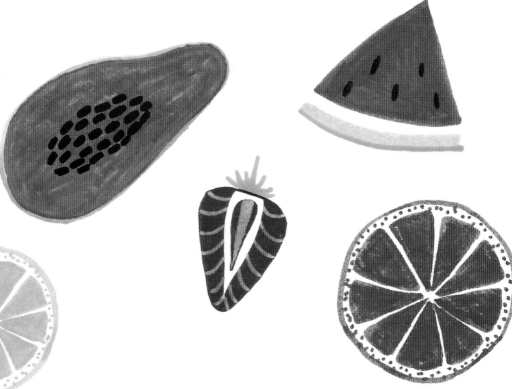

DESSERTS

Now let's draw sweets! Yum!

To draw a simple cupcake, start with the wrapper.

Then add layers of frosting, with a little teardrop shape on top.

Fill in the gaps and draw vertical lines to indicate the side of the wrapper.

Finish by coloring in the cupcake. Create a highlight on one side of the frosting and a shadow on the other.

Combine your fruit- and cake-drawing skills and create a delicious-looking gateau!

Drawing oozing jelly and dripping sauce is similar to depicting shiny fruits like apples (see page 114); achieve the same shininess by adding highlights at strategic points—usually where the sauce drips or pools. If it's easier, use a white gel pen or paint marker to add highlights after drawing the sauce.

To draw a realistic-looking cake, it is essential to capture its texture. You can apply colored pencil over marker, with small dots on top, or use a base color and add randomly shaded patches over it.

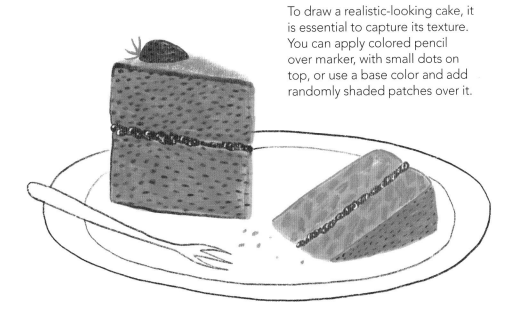

BEVERAGES

Here, I'll show you how to draw a drink in a clear glass, but you can follow the same general steps to draw most beverages. Just change the shape of the glass, and for a hot drink in a mug, draw the liquid peeking over the rim of the cup.

Start with the outline of the glass.

Then draw the top and bottom portions of the liquid using horizontal strokes.

Fill in the rest of the drink using vertical strokes. Darken the sides and bottom of the drink to make it look three-dimensional.

Add a straw and a few curved ripples where the straw meets the surface of the drink.

It would be impossible to include instructions for drawing every single type of food, so I've tried to provide the framework for food drawing. Here are a few more items that may inspire you.

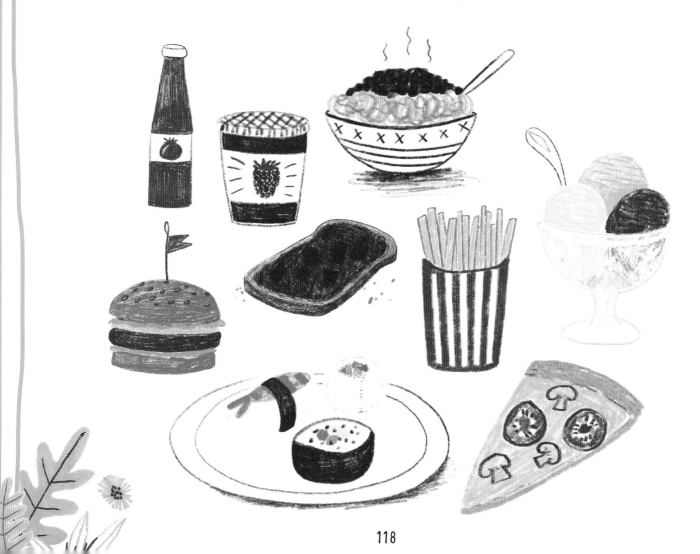

Use your new knowledge to whip up a whole feast!

Still Life Collage

A still life depicts inanimate objects and is often used to study form. Many still lifes are painted, but this still life of a fruit bowl features collage and paint. It's a fun activity to do with your kids, and it creates a frameable piece that you can display!

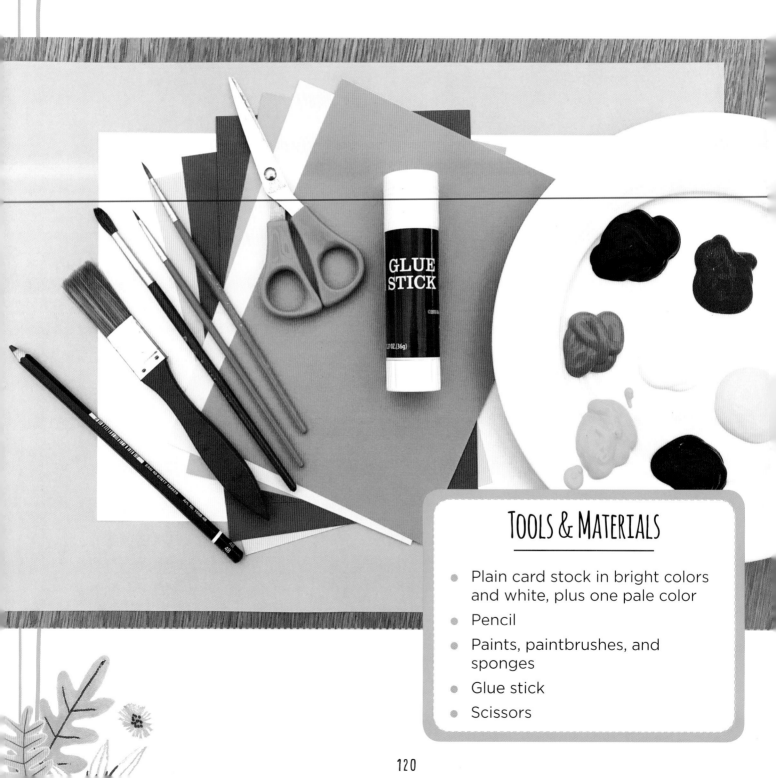

Tools & Materials

- Plain card stock in bright colors and white, plus one pale color
- Pencil
- Paints, paintbrushes, and sponges
- Glue stick
- Scissors

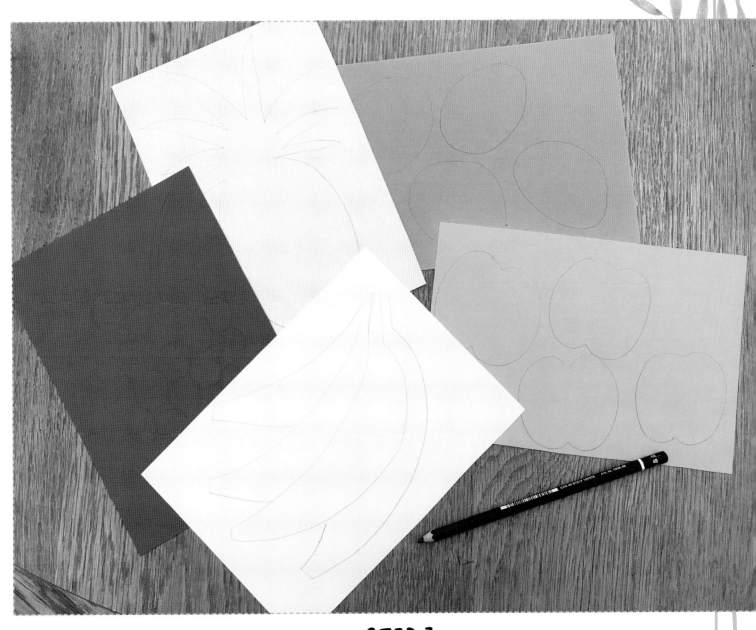

STEP 1

With the help of your child, pick out a few fruits to draw. Then lightly outline them on the colorful sheets of card stock.

STEP 2

Help your child paint details on the fruit. It's fine if the paint goes over the lines; you will cut out the fruit.

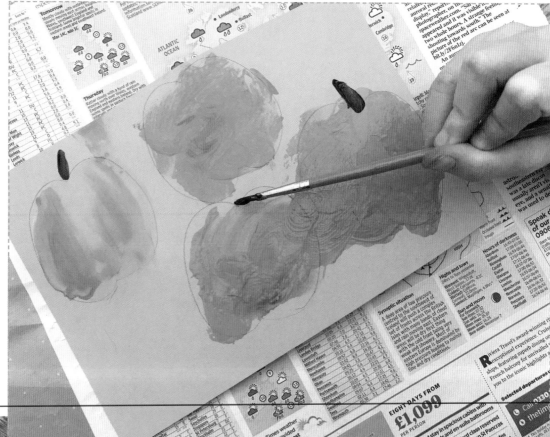

STEP 3

Set aside the painted fruits and let them dry. Draw a bowl on the sheet of white card stock.

I LIKE USING PAINT FOR THIS PROJECT BECAUSE IT ADDS TEXTURE TO THE ARTWORK WHILE OFFERING A NOD TO THE HISTORY OF STILL LIFES AND THEIR PAINTERLY PAST!

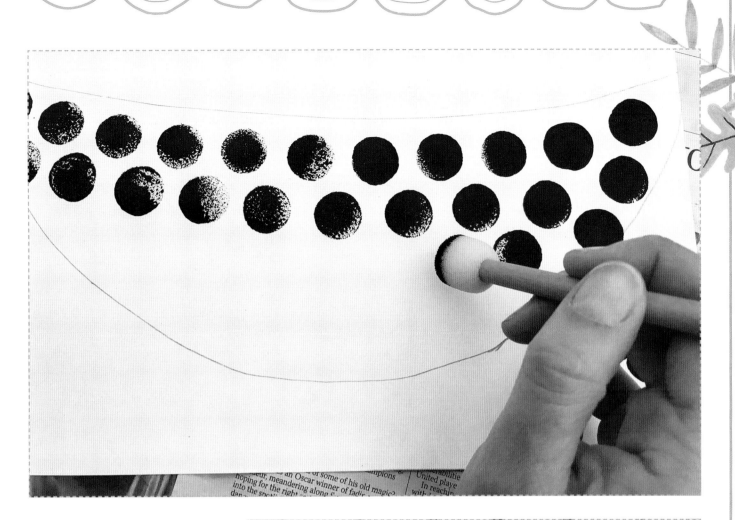

STEP 4

Using dark blue or black paint (or another color that contrasts with the brightly colored pieces of fruit), create patterns on the bowl. Allow to dry.

STEP 5

Now work on the background for your piece. With a paint color that's darker than the sheet of card stock, ask your child to fill half the sheet with paint. On the other half, paint a tablecloth pattern. It can be checked, filled with big or small dots, or anything else you like. Set aside to dry.

STEP 6

Once the pieces of fruit and the bowl are dry, cut them out. Depending on your child's age and dexterity, you can ask him or her to help with this step under your supervision.

STEP 7

Ask your child to help you arrange the pieces of fruit behind the bowl so that it looks like they're in it and that the bowl sits on the tablecloth. Carefully lift the edges of the pieces of fruit, and glue them to the background.

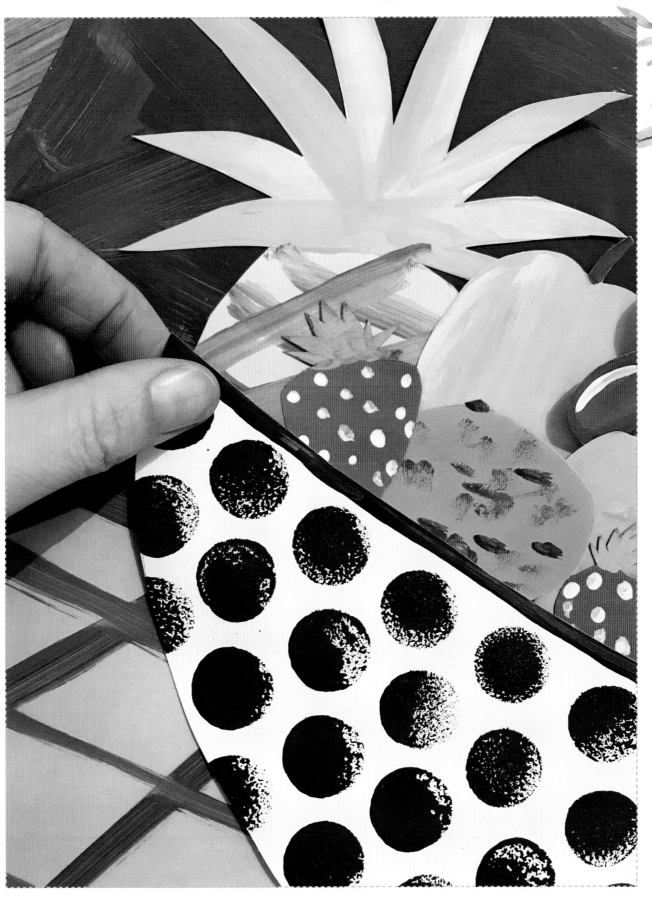

STEP 8

Glue the bowl over the fruit.

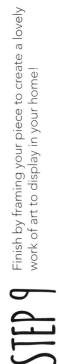

STEP 9

Finish by framing your piece to create a lovely work of art to display in your home!

Glossary

Armature: The framework of a subject or an object.

Composition: How elements are arranged within a piece of art. A balanced arrangement makes the composition pleasing to the viewer's eye.

Drawing from life: Depicting an object, a subject, or a scene that is physically in front of you.

Foreshortening: Capturing a three-dimensional object by showing the natural distortions of shape that are seen with the naked eye when viewed from a distance or an angle.

Form: The depiction of a shape in three dimensions. This can be done by shading for form (using light and dark to create the illusion of a 3D shape). Studying form means to look closely at an object to see how it is shaped before drawing it.

Line drawing: A drawing consisting only of lines and no filled-in or shaded areas.

Mark making: The marks used when making art. These can be lines, dashes, dots, scribbles, textures, and patterns.

Orientation: The way a rectangular painting is positioned. "Landscape" means the width is longer than the height, and "portrait" means the height is longer than the width. Orientation has nothing to do with the artwork's subject matter.

Scumbling: A drawing technique that uses quick little marks in a circular motion to create texture and shading.

Shading: Bringing different tones into your art by building up color to show form. Darker areas appear to recede, and lighter areas come into the foreground.

Sketch: To make a quick, rough drawing of a subject; not usually intended as a final piece but as a quick record or preparatory drawing for a final piece.

Still life: The study of inanimate objects. Still life has a history going back hundreds of years and was traditionally used by artists to explore color, form, and composition in all kinds of subjects, including objects, food, wine, florals, and more.

Tapered line or shape: A line or shape that is thinner at one end.

Vanishing point: The location in a three-dimensional drawing where the perspective appears to disappear into the distance.

Wireframe: Building simple shapes and lines to form the framework of a more complex object.

About The Artist

Lee Foster-Wilson is an artist and illustrator living and working by the sea in rural Cornwall, England, with her husband and young family.

In her artwork, Lee likes to explore patterns, rhythms, stories, the connection of people to nature, and our relationships with each other. Her art can be found on cards, prints, apparel, accessories, and jewelry. Find Lee online at www.bonbiforest.com.

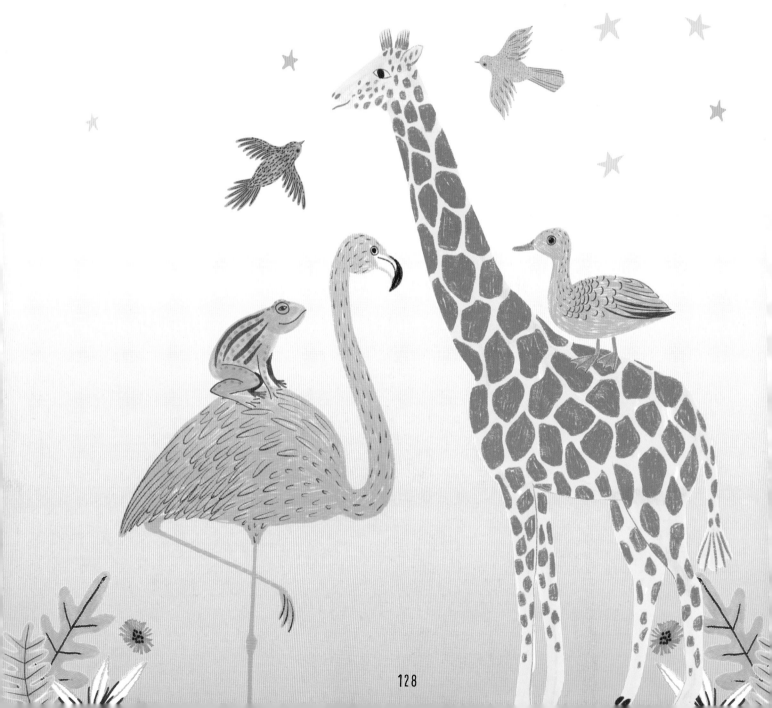